COMPLETE GUIDE TO
PAPER CLAY

COMPLETE GUIDE TO
PAPER CLAY

Mixing Recipes;
Building, Finishing, and Firing;
10 Practice Projects

Liliane Tardio-Brise

STACKPOLE
BOOKS
Essex, Connecticut
Blue Ridge Summit, Pennsylvania

To all creators

STACKPOLE BOOKS

An imprint of Globe Pequot, the trade division of
The Rowman & Littlefield Publishing Group, Inc.
4501 Forbes Blvd., Ste. 200
Lanham, MD 20706
www.rowman.com

Distributed by NATIONAL BOOK NETWORK
800-462-6420

Original French title: *La terre-papier*
© 2008, 2016 Éditions Eyrolles, Paris, France

Layout: Nord Compo
Proofreading: Céledon éditions

British Library Cataloguing in Publication Information available

Library of Congress Cataloging-in-Publication Data available

ISBN 978-0-8117-7069-9 (paper : alk. paper)
ISBN 978-0-8117-7070-5 (electronic)

∞™ The paper used in this publication meets the minimum requirements of American National
Standard for Information Sciences—Permanence of Paper for Printed Library Materials, ANSI/
NISO Z39.48-1992.

Contents

See the complete Table of Contents on page 159.

Releasing clay from many of its technical constraints . . .
Lightening the pieces . . .
Constructing tall, slender shapes . . .
These things ceramicists dream of become a reality with paper clay.

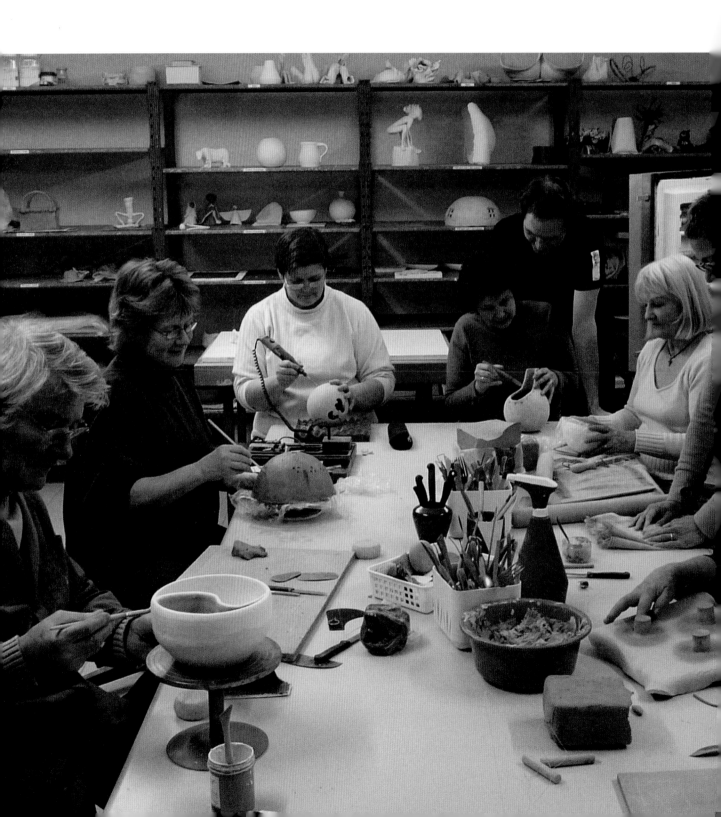

Introduction

How can adding paper to clay, the heir to thousands of years of tradition, reduce its limitations and constraints to such an extent?

Made from defibered plants, paper has the ability to restore the fibers which, composed of cellulose, have a great affinity for both water and clay. Paper clay is thus a composite material in which the clay constitutes a matrix reinforced by fibers. The addition of plant fragments to give body to the clay is an ancient practice, especially in the construction of adobe or mudbrick houses. But the addition of fibers—infinitely smaller pieces—offers interesting ceramic applications in shaping, finishing, and firing. Since the dry pieces are resistant, firing is not required, and paper clay lends itself to unusual artistic and decorative applications.

The first combinations of clay and paper were made by paper makers who had the idea of depositing kaolin on the surface of the sheets of paper during manufacture to make them smooth and shiny. By introducing clay into the paper pulp, the result is sheets that are somewhat refractory.

Research carried out in the 1980s in Australia by Jaromir Kusnik, a Czech, led to the exhibition in 1987 of decorative panels made from a mixture of clay and fibers. The same year, at the *Manufacture de Sèvres*, Jean-Pierre Béranger made sheets of porcelain paper on a screen, a method used by paper-making artisans. The tipping of the proportions between clay and fibers, in very clear favor of clay, led to paper clay. This new material really took off in the 1990s, under the impetus of Rosette Gault in the United States, Brian Gartside in New Zealand, and Graham Hay in Australia. In 1998, Rosette Gault published her research in a book entitled *Paper Clay* and filed a patent in the United States for the marketing of paper clay under the name *P'clay®*.

It is necessary to understand what paper clay is in order to use it wisely and get the most out of it. It shifts away from the technical requirements and discipline of craftsmanship and turns toward artistic expression, as it allows great versatility and freedom of creation. Paper clay is part of the current movement to reuse waste and control energy, since waste paper can be used and a single, quick firing is sufficient.

Paper clay also opens up new horizons for in situ art, which can be dismantled and recycled. Easy to use, followed by simple air-drying, it has its place in introductory workshops, and it opens up new ways of doing things in the area of arts and crafts.

Throughout the pages of this book, you will find practical demonstrations, student pieces, and ceramicists' creations, reflecting the leanings of each and the versatility of this material. It is now up to you to discover paper clay, its possibilities and its limits, the fun of working with it, and the many ways it can be used.

<div align="right">Liliane Tardio-Brise</div>

Part I

An Introduction to Paper Clay

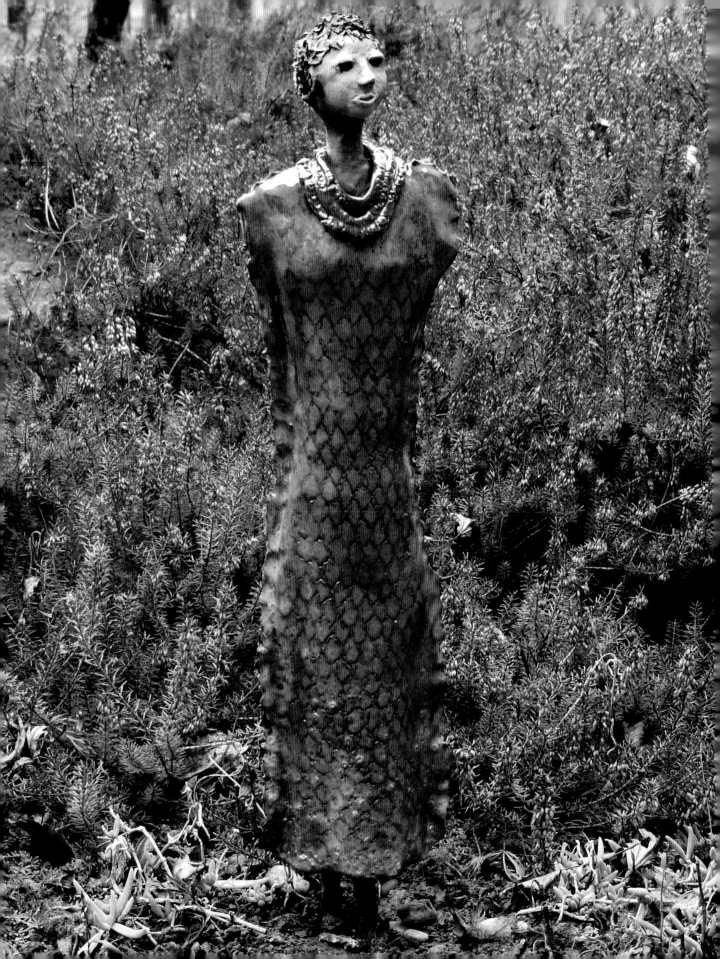

At the Heart of the Matter

Clay and paper are the two essential components of paper clay. In order to understand the characteristics of these materials, you will find in this chapter a careful study of clay, then of paper, and finally of paper clay.

Clay

From a geological point of view, clay is a friable sedimentary rock coming from the erosion of granite. We find clay deposits at all latitudes, deposited by runoff water at the foot of the mountains, in riverbeds, or under arable land. A clay deposit is composed mainly of silica (SiO_2)- and alumina (Al_2O_3)-based minerals chemically bonded by water molecules. The coloring of the mass comes from small quantities of metal oxides and organic debris. The clay has a laminated structure made of hexagonal-shaped platelets. The width of the platelets is on average 0.5 micrometer (1 mm = 1,000 μm). Their size decreases the more they are separated from the rocks from which they came. Each deposit therefore has its own particular characteristics: plasticity, color, and melting point.

When the clay is wet, it forms a compact, plastic, and malleable mass: **potter's clay**. Commercial clays, which come in loaves, are ready to use. Some clays will be white, brown, red, or black; others will be frost resistant or refractory. Yet another type will be used for casting, throwing, or hand-building.

Packaging labels summarize the information that can be found in greater detail in the catalogs and technical data sheets of ceramic product suppliers.

Composition of a Clay Body

The clay body is prepared from one or more clays to adapt it to what the potter wants to use it for. He or she can also improve or compose the mass using **mineral raw materials** purchased from suppliers of ceramic products. These clays have particular characteristics or minerals that improve the firing process. The different components of a clay body react with each other, and it is by playing with their proportions that we can modify plasticity, shrinkage rate, melting point, and strength of the fired clay. For example:

- the addition of a fine clay improves the plasticity of the body, but increases the drying shrinkage;
- adding alumina raises the melting point;
- the addition of an additive such as grog (see p. 15) reduces shrinkage;
- the presence of a flux increases the density of the clay during firing.

Commercial clays.

A porcelain may, for example, be composed of a mixture (by weight) of 55 percent kaolin, 25 percent feldspar, 15 percent quartz, and 5 percent bentonite. Earthenware may contain 65 percent ball clay, 20 percent kaolin, and 15 percent quartz.

The clays listed next are arranged starting with the finest and are followed by the most important minerals commonly used in the composition of clay bodies.

Bentonite

Formula: Al_2O_3-$4SiO_2$-H_2O.

Appearance: Cream-colored powder, formed of extremely fine clay particles (0.05 μm).

Characteristics: High plasticity, absorbs more than twice its weight in water, shrinks a great deal during drying.

Bentonite, added in small quantities, improves the plasticity of a clay body. Bentonite is light in color and is used in the composition of porcelains, not altering their whiteness much. Bentonite also has a high absorption and suspension capacity.

Ball Clay

Average formula: Al_2O_3-$4SiO_2$-$2H_2O$ -$0.1K_2O$.

The proportions of alumina and silica are variable.

Appearance: Cream, brown, or black powder composed of very fine clay particles (0.25 μm).

Characteristics: High plasticity, high affinity for water, overall shrinkage of about 20 percent.

Ball clay is present in many modeling clays, to which it confers a good plasticity. There are different varieties of ball clay containing varying proportions of titanium oxide, iron oxide, and organic compounds.

Kaolin

Formula: Al_2O_3-$2SiO_2$-$2H_2O$.

Appearance: White powder made of clay particles of variable size that can exceed 2 μm.

Characteristics: Low plasticity, very high melting point (1770°C). Also called china clay, kaolin is a very pure primary clay because the deposits are found close to the parent rock. Sought after for its whiteness, it is the main component of porcelain bodies.

Silica

Formula: SiO_2.

Appearance: White powder obtained by grinding quartz or sand.

Characteristics: Improves the vitrification of a clay.

Silica coming from sand contains calcium carbonate. Silica from quartz is of high purity, unlike most minerals that have a complex composition. Glazes are also prepared with silica.

Feldspar

Formula: Na_2O-Al_2O_3-$6SiO_2$ (sodium feldspar) and K_2O-Al_2O_3-$6SiO_2$ (potassium feldspar).

Appearance: White powder from crushed rocks, melting point between 2012 and 2192°F (1100–1200°C).

Characteristics: Improves the fusion necessary to the good strength of fired clay.

Feldspar exists in different forms; the most common are sodium feldspar and potassium feldspar. Feldspars are also used in the manufacture of glazes.

Characteristics of Clay

Once shaped, clay must be dried gradually. Then it will harden irreversibly during the firing process. The exchange of water and changes in the material give it particular characteristics, which are important to know in order to successfully complete the stages of creating a piece.

Plasticity

The main characteristic of clay is its ability to take and keep a given shape. This plasticity is due to the presence of water between the tiny, thin platelets that compose it. The platelets are mobile and slide on each other. The distance between them varies depending on the quantity of water absorbed.

The plasticity of a clay body increases when the clay platelets are small. Thus, the introduction of bentonite in a clay body improves its plasticity. On the other hand, too much plasticity is detrimental when creating large pieces. It can be reduced by adding grog or by cutting with a lean and not very plastic clay.

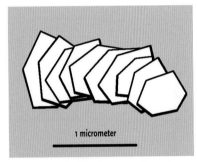

1 micrometer

Clay is composed of a group of platelets.

Consistency

Dry clay, firm and friable, can absorb and release water indefinitely before firing. The consistency of a clay varies depending on the amount of water absorbed and should be adjusted to suit the technique that will be used on the clay. When it is more than 40 percent water, the clay liquefies and becomes slip.

A clay for hand-building must contain about 25 percent water to be shaped. A few percent more or less water will soften or firm up a clay, respectively. Clay used for throwing will be a little softer, while clay used for slab building will be a little firmer.

Hand-building clay and its slip.

Cohesion

In matter, molecules are bonded together by ionic forces that cause cohesion. The moistened platelets that adhere to each other in a slip or a clay body are cohesive. The water they contain, called free water, disappears during the drying process; the platelets come closer together and lose their cohesion. The dry clay is brittle and breaks at the slightest impact. So many pieces are damaged this way during handling, transport, or firing! It is possible to make repairs, but it is not possible to change the shape, as a uniform rewetting of the clay is difficult to control. During the firing process, when the temperature exceeds 1112°F

(600°C), the clay regains its cohesion by transformation of the material. This cohesion increases until the maturation temperature, which confers an optimal solidity to the fired pottery after cooling. At a higher temperature, the clay would soften, then melt.

The fragility of dry clay.

Shrinkage

Crack due to drying shrinkage.

When making items from clay, the ceramicist must constantly take shrinkage, the cause of many technical constraints, into account. When the water evaporates, the clay shrinks. A wet clay—a little soft but not sticking to the fingers—shrinks by about 5 percent during drying. The stresses created by uneven evaporation of water can lead to deformations or even cracks, and only slow drying guarantees an even distribution of moisture in the case of walls that are thick or have varying thicknesses, or of solid pieces. A second shrinkage of about 5 percent occurs during the last phase of the firing process.

Storage

If a loaf of clay dries completely, place it in water for at least twenty-four hours at a rate of one-third of a liter of water per kilo of dry clay. Crush the clay so that it will absorb the water more quickly.

Clay can be stored indefinitely, whether it is dry or wet. The plasticity of clay for hand-building improves over time; keep it in a cool, moist atmosphere. In the workshop or at home, carefully close the package of a loaf of clay that has been opened and place it in a plastic bag or an airtight container so it will keep its consistency. Wrap a clay that has firmed up in a wet cloth before storing.

Storing clay.

Firing

Risk of Exploding

A closed clay wall around an **empty volume** does not resist the strong air pressure exerted during firing. **Residual humidity** resulting from imperfect drying, mostly related to the thickness of the clay walls, irreparably leads to a piece exploding due to steam pressure. The **water content** of the clay can cause the same result if the temperature is raised too quickly. It must therefore be heated up slowly, about 212°F (100°C) per hour over five hours, and the ventilation valve of a kiln must remain open during this first phase of the firing.

Two Firings

Traditionally, two firings are necessary for glazed ceramics. The first, the **bisque firing**, between 1652 and 1832°F (900 and 1000°C), prepares the pottery to receive the glaze suspension: a dry clay wall does not easily withstand the sudden addition of water, which can crack it. The second firing, the **glaze firing**, transforms the glaze layer into a glassy surface.

Effect of firing temperatures on transformation of clay

Firing Temperatures	What Happens?	What Are the Consequences?
Up to 248°F (120°C)	Elimination of residual-free water (it was mainly removed during drying)	Risk of exploding due to steam pressure
392°F (200°C)	Organic matter burns out	Odors
752 to 1292°F (400 to 7500°C)	Water content is driven off	Risk of exploding due to steam pressure
1063°F (573°C)	Quartz undergoes change in crystal structure and expands	The clay particles weld together and the volume of the clay increases; the clay hardens irreversibly and becomes pottery
1292 to 1652°F (700 to 900°C)	Elimination of carbon and some sulfur, which combine with oxygen in the air	Release of CO, CO_2, SO, SO_2, and SO_3; decrease in weight and volume of the clay; the pottery becomes stronger, but remains somewhat porous
1472 to 2372°F (800 to 1300°C)	Gradual vitrification	Shrinkage; the material becomes stronger; risk of deformation

Firing to Maturity

Firing to maturity ensures that the pottery will have greater strength and integrity. This temperature must be adjusted to fit the type of clay, divided into three major families.

Earthenware is fired between 1652 and 2012°F (900–1100°C). Due to its composition, it does not reach the vitrification process without becoming deformed and the pottery then remains somewhat porous. Earthenware pieces chip easily and are not frost resistant. Glazing is necessary to render them waterproof.

Stoneware is fired between 2192 and 2372°F (1200–1300°C). Stoneware is durable, frost resistant, and well suited for making containers. The beginning of vitrification during the firing process gives it strength to resist breakage from impacts. Only highly grogged stoneware remains porous.

Porcelain is fired at around 2372°F (1300°C). It becomes translucent through vitrification. Porcelain pieces, stronger than earthenware or stoneware, are completely waterproof.

Clay Additives

In addition to the basic minerals that make up a clay body, the addition of various materials facilitates building and drying, modifies the appearance of the surface, or reduces the fragility of a dry piece. Clays for hand-building are commonly prepared with grog. Other additives are used for more specific applications.

Grog

Available from ceramic suppliers, grog is mixed with clay by kneading or mixing. It consists of fine pieces of ground fired clay, calibrated by screening to eliminate any particles that are too large.

The grog reduces the plasticity of the clay and gives it strength for building larger pieces. During drying, it does not shrink, so shrinkage of the clay is

decreased. Its presence improves the circulation of air and water, thus limiting the formation of cracks and deformations.

The size of grog particles is chosen depending on the intended use:

- from 0 to 0.2 mm for fine hand-building and throwing;
- from 0 to 0.5 mm for normal hand-building;
- from 0 to 1 or even 2 mm for hand-building of large pieces.

A clay with a high grog content is more resistant to the thermal shock of open fire or raku firing. Most commercially available clays contain 25 percent or 40 percent grog. Highly grogged clays give the pieces a rustic look.

Vase with birds, Liliane Tardio-Brise. Diameter 20 in. (50 cm). Stoneware with high content of large-particle grog. Fired in electric kiln at 2336°F (1280°C).

Molochite

Similar to grog, molochite is made from calcined and ground kaolin. Molochite contains mullite, which makes it possible to increase the pieces' resistance to repeated thermal shocks, a useful property especially for culinary ceramics. Thanks to its white color, it blends well with light-colored bodies such as porcelain. However, its cost is higher than that of grog.

Sand

Sand is composed of silica and traces of various minerals. Nature offers a number of varieties of sand of different colors, granularity, and composition. Sand acts like grog. But when it contains limestone, the pottery can be affected by the formation of quicklime and crumble under the effect of heat.

Black sand in red clay. Fired at 1832°F (1000°C).

Sand gives a grainy appearance to a clay wall and can be applied to the surface. When the clay is fired, some sands vitrify.

Deflocculant

This product can be found ready to use at ceramic suppliers. The addition of a deflocculant fluidizes the clay by adding electrolytes that act on the spacing of the platelets and on their alignment. For example, a deflocculant is commonly used to prepare casting slip. It increases the density of the slip by reducing the volume of water added to the clay powder. The setting time of the slip in contact with the plaster is thus reduced.

A defloculant: Dolaflux.

A deflocculant, Dolaflux for example, should be used sparingly, at a proportion of about 2 g of defloculant per kilo of dry clay. It needs to be diluted in a little warm water before use.

Resin

The addition of a hardener in a clay body without grog helps remedy the problem of cohesion of the clay after drying. Thus resin has become part of the composition of self-hardening clay, often used in schools. When the clay dries, the hardener acts as a glue that strengthens the shaped mass. It then becomes hard as if it had been fired. However, this clay does not stand up well to prolonged contact with water, unless it is protected by a varnish or glaze. It is reserved for small-sized decorative objects and sold ready to use at suppliers of ceramic products or in arts-and-crafts stores.

Metal Oxides and Pigments

The natural color of a clay deposit depends on the **metal oxides** and organic residues present. During firing, the organic residues burn and can change the color of the clay. The addition of metallic oxides can enhance a color or bring color to a white clay. Black clay is rich in manganese oxide, red clay in iron oxide.

Available in various colors, **pigments** kneaded into the clay tint clay bodies used in the neriage technique (a decorative process creating patterns with different colored clays together).

Metal oxides and pigments come in the form of fine powders in several colors from suppliers of ceramic products.

When handling dry metal oxides and pigments, remember to wear a mask to protect against fine dust.

Iron oxide.

Marbled effect from kneading white, red, and black clay, fired at 2336°F (1280°C).

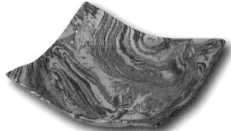

Plate by Clémence Lang. Clays colored with pigments, then mixed by kneading. Transparent glaze, fired at 1832°F (1000°C).

Perlite

Perlite is a siliceous rock. Crushed and calibrated, it is expanded in furnaces where it swells to four to twenty times its original volume. Expanded perlite comes in the form of small, very light white granules from 1 to 4 mm in diameter. It is used in the building industry to lighten concrete and improve thermal and sound insulation, as well as in horticulture because it supports exchanges between air and water.

Clay containing 2 percent perlite, after firing at 2336°F (1280°C).

Ceramicists use expanded perlite to reduce thermal shocks during pit-firing and raku firing. It is kneaded into the clay body to reduce the latter's density. But, in return, it greatly reduces plasticity. The use of expanded perlite is desirable when building large pieces, which it lightens, and for the particular appearance that it gives to the walls. The granules melt around 2012°F (1100°C), and the surfaces are riddled with holes after firing at 2336°F (1280°C).

Clay containing 2 percent vermiculite, after firing at 1832°F (1000°C).

Vermiculite

Vermiculite is a mineral composed of aluminum-magnesium silicate minerals with a clay-like structure. After grinding and calibration, vermiculite is heated. Steam pressure causes it to expand and form little grey-brown laminar chunks, both light and friable, that can be up to 8 mm. The stored air gives exfoliated vermiculite

thermal and acoustic insulation capacities. Like perlite, it is used in the construction industry for insulation, the production of light concrete, protection against fire, and by horticulturists for its ability to absorb water.

The ceramicist uses exfoliated vermiculite to lighten the clay, even though it reduces the plasticity of the body. The laminar pieces break easily during kneading and form golden inlays on the surface of a clay fired at 1832°F (1000°C). Vermiculite melts at 2462°F (1350°C).

Plant Fragments

Straw.

The cob appears under the surface coating.

The cob of old, traditional wood-frame houses is made of clay mixed with straw. The clay acts as a binder and the straw improves cohesion, forming a kind of armature. The cob has good insulating properties. A surface coating protects against moisture. Raw earth houses are built with a mixture of clay and gravel mixed with plant fragments compacted in forms (rammed earth) or shaped into bricks (adobe), dried in the sun before being erected.

Crushed Plants, Sawdust

The sawdust produced from cutting wood contains clusters of crushed plant fibers. Mixed with clay, it reduces its density, but also its plasticity when it is at 2 percent of the content. Very fine, almost like a powder, or coarser, the sawdust burns during firing, leaving a lighter and more porous structure with enhanced insulating properties. The crushed plants are used in particular for the manufacture of bricks and tiles.

With Nothing But, *Anne-Marie Schoen. This 13 in. (33 cm) cube combines lightness and upheaval. Combination of grogged stoneware with inclusions of sand, ash, and wood chips. Fired in electric kiln at 2336°F (1280°C). Photo by A. Zorninger.*

Synthetic Fibers

Nylon and polyester can be introduced into the clay by kneading. These very strong, inert, and solid fibers have little affinity with water. However, they bring good cohesion to a dry clay body or a hand-building clay, without changing the appearance of the clay, and are stable over time. However, they produce noxious fumes during the firing process.

There are ready-to-use clays containing **nylon fibers** a few millimeters long. Used for occasional workshops, the pieces are simply dried and then decorated with acrylic paint or gouache. They need to be varnished to protect them from water.

Originating from batting or stuffing material, **polyester fibers** are made up of fibers several centimeters long. This makes the use

Polyester fibers.

of traditional shaping tools tricky, as these long fibers easily pull away from the clay body. The fibered clay can be rolled or stretched out into very thin sheets and cut with scissors.

Mineral Fibers

Glass fibers.

Silica-based **glass fibers** are used to increase the cohesion of clay. During their manufacture, glass is melted (2732°F/1500°C), then stretched into very fine filaments (5 to 13 μm) during cooling. Glass fibers used in the textile industry are then coated with a protective resin that makes them less fragile. Several tens of centimeters long, they are shortened by tearing and are integrated into the clay by kneading. Very thin slabs for draping can be made with the addition of these inert, solid glass fibers. With the high firing temperature, the fibers melt without resisting deformations.

Alumina silica-based **ceramic fibers** are very fine artificial mineral fibers (1 to 3 μm in diameter). They are used for the insulation of high-temperature kilns and furnaces. They can reinforce a clay body, especially since this effect remains during firing. Gloves and masks must be worn for protection from the fine fiber dust released during handling.

A very fluid piece of draping.

Plant Fibers

Drained paper pulp.

Cellulose-based fibers obtained by defibering a plant introduce very particular qualities once mixed with clay. The easiest to release are those from paper, which is broken down by vigorous stirring in a large volume of water. Once drained, this paper pulp is mixed with a clay slip, and the excess water is removed (see p. 51). The cohesion and hydrophilicity of the resulting **paper clay** make it easier to shape the pieces. It is resistant against drying shrinkage and gives a very good solidity to the dry pieces, which can be kept as they are or can be glazed directly.

The cellulose fibers are burned during firing and form a microporous wall resistant to the thermal shock of pit-firing and raku firing (see p. 111). The presence of fibers does not change the appearance of the clay, and all ceramic decoration techniques are applicable, but shelf life is limited in the wet state. The particular properties of paper clay open the way for new types of clay-based creations. In this book, we will focus on these properties.

Which clays can be used to prepare paper clay?

Dry crushed, in ready-to-use powder form or a mixture of minerals, whether it contains additives or not, any traditional clay—earthenware or stoneware—can incorporate fibers originating from paper. Adding fibers to porcelain expands its applications beyond casting and throwing.

Paper

Paper is a writing and printing medium, used for wiping or packaging, and comes in flat, smooth sheets. It is made of a multitude of small agglomerate fibers—visible when torn—mainly composed of cellulose from plants. These fibers, separated with water, are used to prepare paper clay.

At the beginning of this era, the Chinese made paper with bamboo and mulberry bark fibers. In the eleventh century, in Europe, paper was made from hemp and flax. Then the use of wood made it possible to develop and diversify production.

The length and composition of the fibers depend on the plants from which they come. The composition of paper varies according to the origin of the fibers, the type of pulp, and the additives used. Paper is present everywhere in our lives for all sorts of specific uses, and it can be usefully recycled by becoming part of the preparation of paper clay.

Surface of newsprint (magnification 5).

Torn newsprint (magnification 10).

Surface of toilet paper (magnification 5)

From Plant to Fibers

Fibers are separated from a plant to make a paper pulp by using a lot of water, energy, and chemicals. The fibers of non-woody plants can be processed traditionally, by hand. Tree fibers, both hardwood and softwood, require industrial processing.

Handmade Pulp

Shredded herbs, leaves, flowers, or cotton or linen fabrics are boiled in an alkaline solution—prepared with ashes or caustic soda—to obtain a handmade pulp. A well-ventilated room, gloves, and protective goggles are essential for this process. Once liberated, the fibers of varying lengths are drained and washed.

Virgin Pulp

The preparatory work of transforming plantation wood, sawmill waste, and wood from thinning of timber into paper pulp is done at the mill, using different processes. If the wood is only defibered, a **mechanical pulp** is obtained that retains all the components of the wood. Its yield is 90 percent. This pulp is used for newsprint and cardboard, and it is used in varying proportions in various other papers to reduce cost. Mechanical pulp-based papers age poorly (see lignin paragraph, p. 22).

If the lignin and hemicelluloses are removed from the wood, a **chemical pulp** is obtained. Defibration is a multi-step process that requires chemicals—which are then recycled. The process is longer and the yield is lower, about 50 percent. The pulp obtained is of good quality; it results in strong paper with a good lifespan. Its cellulose purity is similar to that of traditional paper pulp made from rags. Magazine, printer, and writing paper contain chemical pulp in varying proportions.

Recycled Pulp

Paper collected and sorted for recycling is transformed into recycled pulp. This waste paper becomes a new raw material. Printed papers coming from batches of the same product (unsold magazines and newspapers) provide papers of the same type after deinking. A lot of waste paper is transformed into cardboard packaging. Recovered cellulose fibers have a variety of uses; for example, fireproof cellulose wadding is used for building insulation. Repeated recycling of paper reduces its mechanical quality, and the addition of virgin pulp fibers is necessary to improve it.

Plant Fibers

Fibers are elongated, slender cells. Softwood fibers, commonly used in the paper industry, are on average a hundred times longer than they are wide, about 3 mm for 30 μm. **Plant fibers** have a tubular structure that contains a cellular lumen acting as a reservoir; they have the capacity to absorb water by swelling. Consolidated in a network, they are the support organ of plants.

In their free state in **paper pulp**, the fibers become cohesive when they are pressed and dried to form a sheet of paper. Each plant has specific fibers made primarily of cellulose, hemicellulose, and lignin. The composition and length of the fibers vary from plant to plant, but they have similar characteristics.

Bales of recycled paper.

Strong, sturdy fibers

The fibers of the plants we eat are necessary for the proper functioning of the intestinal tract, but they are not assimilated by the body. They are very strong, insoluble in water, and resistant to many chemical agents. Only herbivores and certain micro-organisms produce enzymes capable of breaking them down so that they can be assimilated.

Cellulose

All plants produce cellulose—necessary for their growth—by photosynthesis. This natural polymer with long linear chains is composed of a succession of glucose molecules as illustrated by its formula: $(C_6H_{10}O_5)_n$. The subscript n indicates the variable number of repetitions of glucose. In cotton, for example, n is greater than fifty thousand.

Portion of cellulose macromolecule composed of glucose molecules.

These macromolecules, grouped together in parallel, form microfibrils that are solidly welded together in crossed or helical layers. They form the walls of the fibers, which are in turn bound together and form a plant. Cotton produces fibers containing 90 percent cellulose, while the wood used by the paper industry contains 40 percent to 50 percent.

The hydroxyl (OH) groups of cellulose molecules are the active part of the fiber. They bind water and move apart the microfibrils, causing the fiber to swell. During the preparation of paper pulp, the bonds on the surface of the fiber become hydrated until they separate. In the industry, this operation is done in pulpers and is followed by a refining process that mechanically breaks down the surface wall of the suspended fibers to release fibrils and increase contact points. As the fibers dry, they bond together more easily and give the paper cohesion. The fibers used to make newsprint are highly refined; those used to make toilet paper are not.

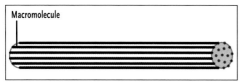

Microfibril made of a grouping of cellulose macromolecules. Diameter 2 to 10 nm.

Hollow vegetable fiber with walls made of consolidated layers of microfibrils. Diameter 7 to 50 μm.

Hemicellulose

Hemicelluloses have a similar structure to cellulose, but the chains are shorter and branched. They cover the surface of microfibrils and act as an adhesive with the lignin. Wood contains 25 percent to 30 percent hemicellulose, which will be eliminated in the manufacture of chemical pulps.

Lignin

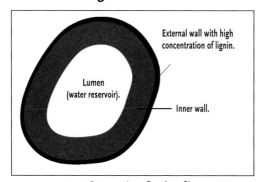

Cross-section of a plant fiber.

Lignin is necessary for the growth in height of a plant, and plants that do not grow tall thus contain little of it. A phenolic compound, lignin forms the weft of a network stiffening the fibers.

Fibers from the seeds of the cotton flower do not contain lignin; those of flax, from the stem, contain less than 1 percent. On the other hand, it can be as high as 30 percent in wood from trees. Lignin is more concentrated at the periphery of the fibers and reduces the permeability of their walls.

While lignin performs well in firewood, it is not welcome in paper, as it makes it sensitive to light. Paper containing lignin ages poorly, turns yellow, and becomes brittle. Lignin is eliminated during the preparation of chemical pulps to obtain quality papers.

Other Components

Plants contain various substances in small quantities, including **minerals**—calcium, potassium, magnesium, sodium—that remain in the ash after combustion, and that vitrify at 2336°F (1280°C) (the firing temperature of stoneware and porcelain).

Softwoods contain **resin**. **Gums** and **tannins** are burned during the firing of the clay.

Fiber Length

All common papers come from wood and are a mixture of short (1 mm for hardwood) and long (3 mm for soft, resinous wood) fibers, in varying proportions. The long fibers give the paper body and strength, while the short fibers give the paper a good, uniform formation and are less expensive.

Fibers from plants such as cotton, flax, or hemp are on average ten times longer than those from wood. Sturdier, they are reserved for the manufacture of quality papers, thin and solid like banknotes, or with particular absorbing properties like watercolor paper.

Comparison of the size of some plant fibers, from the shortest to the longest

Plants	Fiber Length	Fiber Thickness
Hardwood (eucalyptus, poplar, birch)	0.03 to 0.05 in. (0.8 to 1.2 mm)	14 to 23 μm
Wheat straw	0.05 to 0.06 in. (1.2 to 1.5 mm)	7 to 15 μm
Jute (stem)	0.08 to 0.12 in. (2 to 3 mm)	about 16 μm
Softwood (pine, spruce, fir)	0.12 to 0.14 in. (3 to 3.6 mm)	36 to 39 μm
Kapok (flower)	0.6 to 1.2 in. (15 to 30 mm)	about 20 μm
Hemp (stalk)	0.39 to 1.6 in. (10 to 40 mm)	10 to 50 μm
Flax (stalk)	0.39 to 2 in. (10 to 50 mm)	20 to 30 μm
Cotton (flower)	0.6 to 1.8 in. (15 to 45 mm)	20 to 30 μm
Ramie (stalk)	1.2 to 6.7 in. (30 to 170 mm)	20 to 50 μm

2 cylinders, scoops, bases, Carol Farrow. Long cotton fibers mixed with white clay and red clay allow the shaping of extremely thin walls. Wash of clays and oxides. Fired in electric kiln at 2300°F (1260°C).

From Fiber to Paper

The manufacture of paper must meet cost, strength, and absorption criteria. Spread out in a thin layer, the cellulose fibers are pressed, then dried to form a sheet of paper. Handmade and therefore prepared without treatment, the sheet tears easily, its surface is irregular, its color is dull, and the ink spreads through the fibers. To avoid this, the paper maker bleaches the pulp and adds various products during the manufacturing process so that each paper has properties adapted to its use.

Making paper by hand.

Apart from mineral fillers, additives and inks from waste paper are consumed during the firing of paper clay.

Mineral Fillers

They each have specific properties, for example:

- **titanium dioxide** (TiO_2) increases the whiteness and opacity of paper;
- **kaolin** ($Al_2O_3 \cdot 2SiO_2 \cdot 2H_2O$) and calcium carbonate ($CaCO_3$), or chalk, added in significant quantities, improve the smoothness and printability of paper;
- **talc** ($3MgO \cdot 4\ SiO_2 \cdot H_2O$) and gypsum ($CaSO_4 \cdot 2H_2O$), added in small quantities, facilitate the smoothness of the paper.

Magazine rolled and burned at 1832°F (1000°C).

Mineral fillers can make up to 30 percent of a paper's weight. They have a high melting point and do not burn like fibers. They therefore interact with the components of a clay body during firing. For example, a mixture of porcelain and fibers from office paper (containing calcium carbonate) during firing forms a feldspar, anorthite ($CaO \cdot Al_2O_3 \cdot 2SiO_2$), whose high melting temperature (2822°F/1550°C) delays vitrification.

Sizing Agents

Synthetic or natural resins such as rosin are used as sizing agents. They make the fibers adhere to each other, make the paper less absorbent, and prevent the inks from spreading.

Additives

Additives are added in small quantities to the pulp during the paper manufacturing process. They include **dyes** to tint the paper, **whiteners** to give the paper an intense white color, and **starch** to strengthen the internal cohesion of the sheets by making them more solid. A large number of additives are used in the papermaking process.

From Paper to Fiber

The more tear-resistant a paper is, the more difficult it will be to break down. To release the fibers, the paper must first be shredded, soaked in a large amount of water, and then stirred vigorously.

Paper pulp contains 1 percent to 2 percent fibers. It has a somewhat fleecy appearance, with no visible shreds or colored spots. Once drained, the paper fibers form a pulp composed of fibers and the various components of the paper (most of which are insoluble in water), as well as ink if printed waste paper is used.

Newspaper after soaking in water for twenty-four hours.

Paper pulp after vigorous stirring.

The pulp obtained after draining.

Newspaper

Characteristics: Newspaper from daily papers is mostly made from mechanical pulp or recycled pulp. Its strength is obtained by compressing the fibers, whose high level of refining increases their capacity to retain water. These fibers are not very rigid and produce a paper clay slip that is barely lumpy at 3 percent. Besides cellulose, it contains lignin and hemicellulose. It leaves about 10 percent residues that vitrify at 2336°F (1280°C). The printing ink disappears for the most part during firing.

Newspaper and its liberated fibers (magnification 50).

For paper clay: At best, newspaper reduces the density of paper clay. It is particularly suitable for preparations with high fiber content. A mixer or blender (see p. 50) is essential.

Paper Towels, Napkins, Tissues

Characteristics: These types of paper products are made from cellulose wadding obtained through a manufacturing process that flakes fibers from virgin or recycled pulp. Paper towels, napkins, and tissues are both strong and absorbent. The manufacturing processes make them particularly strong and difficult to break down.

For paper clay: These types of paper are not suitable for making paper clay.

Toilet Paper

Characteristics: At once light, flexible, and absorbent, it is composed of thin layers of cellulose wadding. The fibers have not been refined and therefore separate quickly in water (in order to facilitate the evacuation of wastewater). Colors or fragrances do not affect the quality of the pulp obtained. At equal concentration, the paper clay slip obtained is lumpier than that prepared with other papers. Toilet paper contains few additives and therefore leaves only traces of residue when burned. There are a few differences from one paper to another:

- Cheap toilet paper breaks up quickly in cold water. Made from recycled waste paper, it contains few long fibers.
- The more luxurious toilet paper is made from a chemical pulp in which short fibers are mixed with long fibers to provide softness. Warm water makes the preparation easier.

Toilet paper and its liberated fibers (magnification 25).

For paper clay: Toilet paper is the **ideal paper** to quickly make a few kilos of paper clay at home with little material, or to prepare paper clay slip quickly for a repair.

Office papers and their liberated fibers (magnification 25).

Advertising flyers and their liberated fibers (magnification 25).

Magazines and their liberated fibers (magnification 25).

Egg cartons and their liberated fibers (magnification 25).

Office Paper

Characteristics: A waste paper basket contains various types of paper: printed sheets, envelopes, etc. Once sorted and with staples and adhesive strips removed, the waste paper can be used to prepare paper pulp. Mainly made from chemical pulp, they contain sizing agents and mineral fillers such as calcium carbonate. They do not contain much ink, but do not break down as easily as newspaper. They contain mineral fillers and therefore have a lower fiber content.

For paper clay: These papers can be used, provided that a sturdy mixer is available.

Weekly Papers and Advertising Flyers

Characteristics: Most weekly newspapers and advertising flyers are printed on recycled pulp-based papers. They tear easily and fall apart like newspaper. The inks tend to form colored clumps in the pulp. They contain high mineral fillers and few long fibers. When burned, they leave about 25 percent ash.

For paper clay: Use these types of printed paper if you need large quantities of paper clay with a high fiber content. Be sure to break them up well with a blender or mixer.

Glossy Brochures and Magazines

Characteristics: Photo reproduction requires quality, white, smooth papers. They are often thick and glossy with a high mineral content, kaolin in particular. These glossy papers resist hot water and take a long time to break down. They leave at least 25 percent residues when burned.

For paper clay: These papers are not recommended. If necessary, use a professional mixer.

Cardboard Packaging

Characteristics: Printed flat cardboard food packaging is a hybrid product made of several layers of paper. Packaging for liquid products is covered with polyethylene and aluminum films to make them waterproof.

For paper clay: Do not use these very resistant and complex cardboards.

Corrugated Cardboard and Egg Cartons

Characteristics: The strength of these types of cardboard is ensured by a high proportion of long fibers. Corrugated cardboard is composed of several layers of thick paper glued together. Egg cartons and trays are made from molded cellulose fibers.

For paper clay: These types of cardboard require a long soaking time and a very powerful mixer to break down their fibers, but it is possible to recover mostly long fibers from them.

Paper Clay and Its Properties

Mixtures of clay and paper pulp fibers are marketed ready to use under various names: paper clay, porcelain paper clay, cellulose clay, fiber clay, or flax paper clay (with flax fibers). These paper clays have an average fiber content of about 3 percent, calculated by dry weight.

Paper clay is prepared by hand with clay in the form of a slip, to which drained paper pulp is added. The added fibers will modify the properties of the clay, but the appearance, color, and firing temperature remain similar to those of the clay used.

The fibers burn up between 446 and 842°F (230–450°C) and leave a porous structure that gradually closes at the end of firing. Some simple experimentation with a precision balance, a ruler, and a graduated cylinder can reveal the properties of clays and be used to observe how a preparation changes when the quantity of paper added goes from 0 percent to 10 percent.

At 5 percent, the plasticity of a clay is significantly reduced. But at more than 10 percent, the mixture forms a kind of papier-mâché, which is no longer in the scope of investigation of this work.

The fibers increase the cohesion of the clay and its resistance to drying shrinkage. The technical constraints related to the risk of cracks or breakage are reduced and leave a great freedom during the shaping process. The fibers retain water, and the density of the paper clay is reduced. Many decorative techniques (glazing, polishing, painting, etc.) may be used with paper clay, whether or not it is fired.

Resistance to Drying Shrinkage

Distinctive Characteristics

A traditional clay for hand-building contains about 25 percent water (250 g of water in 1 kg of clay). As it dries, the water evaporates, causing a linear shrinkage of about 5 percent (see p. 30). When shrinkage is inhibited, the clay cracks or breaks.

When fibers are present, the clay wall resists the force of shrinkage generated by drying, as the clay-coated fibers hold the mass together by creating bridges when a crack forms. The resistance to shrinkage increases with the amount of paper added. At 1 percent, the effect is slight, but when it reaches 10 percent, the formation of cracks is negligible.

Close-up of a crack and its small fiber bridges (magnification 10).

Experiment

With paper clay, the paper ratio indicated is the weight of dry paper added to the weight of dry clay. A 3 percent paper clay is composed of 1 kg of dry clay, 30 g of paper, and the amount of water necessary to be able to shape the clay.

Plywood square and clay square before assembling.

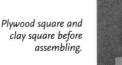

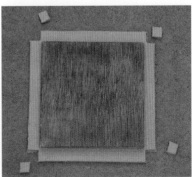

Clay surrounding the plywood on five sides before drying.

For this experiment, 6 in. (15 cm) squares were cut out of clay slabs spread out to a thickness of 0.2 in. (5 mm). A 4.7 in. (12 cm) square of plywood with a thickness of 0.4 in. (1 cm) was placed on each clay slab. The clay was placed up along the edges of the plywood and the fitted corners were carefully joined together. Then the clay was trimmed to the level of the wood. The squares were left to dry in the open air.

This experiment showed that, in the absence of fibers, the breaks occur at the edges of the wood and one or even two sides cracked and fell off.

With fibers present in the clay, only the four corners crack, and the size of the cracks decreases as the fiber content increases. Once the piece of plywood is removed, the cracks in the paper clay are easily closed, unlike non-fiber clays, which are very brittle.

The resistance to drying shrinkage reduces the formation of cracks during drying, allowing for work on armature, joining pieces with varying degrees of moisture, embedding, and inclusions of various materials.

Coral, Thérèse Lebrun. Light shaft resulting from a work of porcelain paper clay by covering supports and embedding materials. Photo by P. Gruszow.

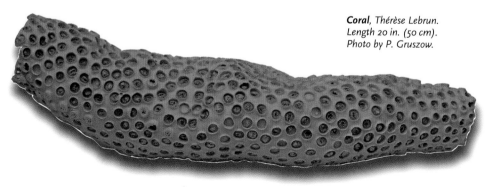

Coral, Thérèse Lebrun. Length 20 in. (50 cm). Photo by P. Gruszow.

Results obtained with different types of clay

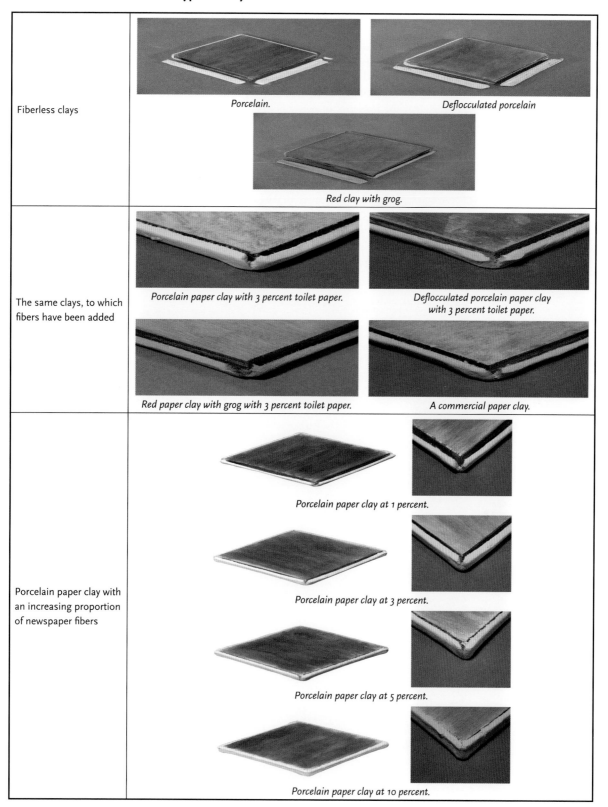

Fiberless clays	*Porcelain.* *Deflocculated porcelain* *Red clay with grog.*
The same clays, to which fibers have been added	*Porcelain paper clay with 3 percent toilet paper.* *Deflocculated porcelain paper clay with 3 percent toilet paper.* *Red paper clay with grog with 3 percent toilet paper.* *A commercial paper clay.*
Porcelain paper clay with an increasing proportion of newspaper fibers	*Porcelain paper clay at 1 percent.* *Porcelain paper clay at 3 percent.* *Porcelain paper clay at 5 percent.* *Porcelain paper clay at 10 percent.*

Drying and Firing Shrinkage

Distinctive Characteristics

When a paper clay dries without being slowed down by a support, it shrinks, just like traditional clay. It also shrinks during the firing process, as it approaches the maturation temperature of the clay.

These two shrinkages one after the other together amount to 10 percent to 15 percent (for a porcelain). The presence of paper fibers increases this linear shrinkage.

Experiment

Various wet clays, with and without fibers, are carefully rolled out to a thickness of 0.2 in. (5 mm) and cut into 4 in. (10 cm) squares; the squares are placed on chipboard and allowed to dry.

These squares are measured after drying, after firing at 1832°F (1000°C), and after firing at 2336°F (1280°C). Calculation of the shrinkage rate: if a square is reduced from 10 to 9.5 cm on a side during drying, we say that it has shrunk by 5 percent.

Wet/dry/after firing at 1000°C/after firing at 1280°C

Porcelain (on bottom) and the same porcelain after adding 3 percent toilet paper (on top).

Red clay with grog (on bottom) and the same red clay after adding 3 percent toilet paper (on top).

Comparison of shrinkage depending on the clay used

The clays are tested at a wet/plastic stage.

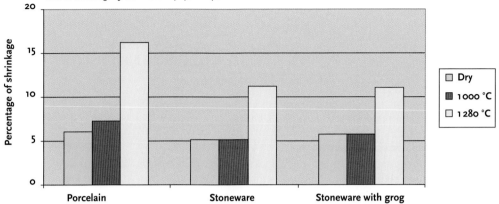

Linear shrinkage of commercial paper clays.

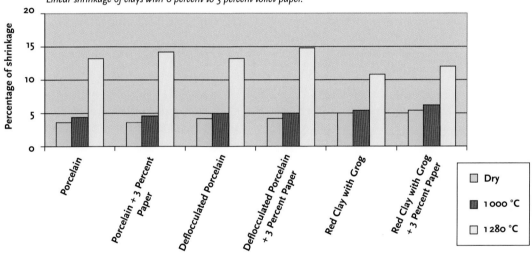

Linear shrinkage of clays with 0 percent to 3 percent toilet paper.

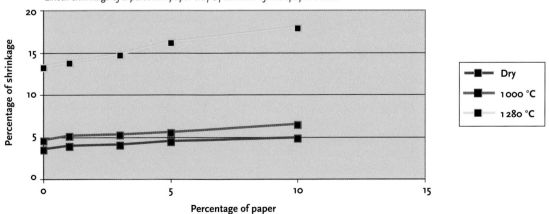

Linear shrinkage of a porcelain paper clay by amount of newspaper added.

It can be seen that, during both drying and firing, the linear shrinkage of a paper clay increases with the fiber content. The increase in shrinkage is explained by the decrease in the proportion of clay to the fibers and the amount of water they bring into the clay body (see hydrophilicity, p. 36). The shrinkage of medium fiber paper clay is similar regardless of the type of paper used (toilet paper, newspaper, or office paper).

When drying, shrinkage causes cracks that can put a piece at risk when the clay does not contain fibers. With paper clay, this disadvantage is compensated by the resistance to shrinkage, which reduces the formation of cracks, as well as by the cohesion and hydrophilicity of the fibers, which make repairs easier.

Deformations

Distinctive Characteristics

During drying and firing, paper clay is subject to deformation just like traditional clay.

Also, **wet slabs** must be handled with care to keep them flat; otherwise a twisting when they are shaped could reappear when drying. Slabs around 1/8 in. or a few millimeters thick are exposed to deformations caused by drying stresses, especially when they dry quickly around the edges.

For **sculpted or hand-built pieces** that are thick or have different thicknesses, the drying stresses balance out and the paper clay pieces can be air-dried without concern.

Firing deformations occur at temperatures close to the maturation temperature of the clay and are most likely to occur in thin-walled or slender forms that can bend under their own weight.

Experiment

Small slabs of clays and paper clays 1.5 x 4.7 in. (4 x 12 cm) and 0.12 in. (3 mm) thick are set out to dry flat, then placed in the kiln on kiln posts. The deformation observed is the deviation in millimeters of the central part. The slight thickness of the slabs highlights the deformations caused by the firing and makes it possible to compare these clays.

Comparison of the deformations by type of clay used

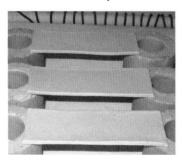

Slabs before firing.

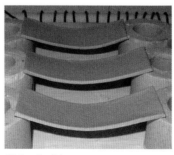

Slabs after firing.

Measurement of the deformation.

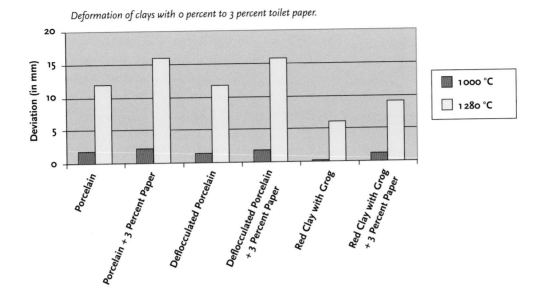

Deformation of clays with 0 percent to 3 percent toilet paper.

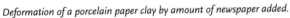

Deformation of a porcelain paper clay by amount of newspaper added.

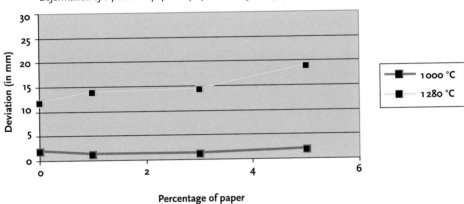

Deformation of commercial paper clays.

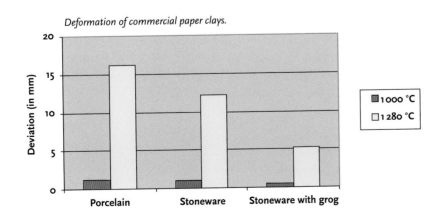

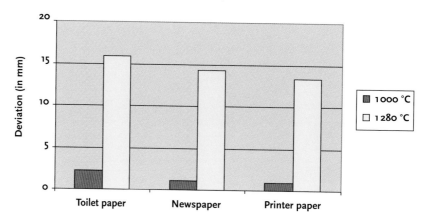

Deformation of a porcelain paper clay at 3 percent.

At 1832°F (1000°C), there is only a slight deformation of the slabs, whether the clay contains fibers or not. At 2336°F (1280°C), deformation of the fibrous clays increases with the amount of fibers added, even until falling from their supports at 10 percent. The presence of fibers causes a decrease in the proportion of clay and exposes it to deformations. The deformations vary depending on the paper used.

Because of the cohesion of paper clay, it is possible to reduce wall thickness. However, it must be thick enough to ensure the stability and strength of a piece. Thus a large piece will be highly exposed to deformation during firing if its walls are thin and if its base is not reinforced. Adding grog or lowering the firing temperature reduces deformation.

Cohesion in Wet and Dry States

A plant is made up of fibers that are very cohesive and difficult to separate (see p. 20). In paper, they amass in thin layers, and water and energy are necessary to break them up again (see p. 49). If the volume of water decreases, the fibers cling to each other. In paper clay, the fibers spread out in the mass and give it cohesion.

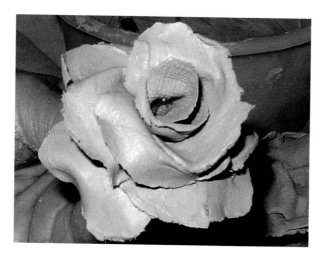

A delicate, finely constructed rose, easy to manipulate.

At equal concentration, the cohesion of paper clay is greater when the fibers are long. With increasing concentration, the cohesion increases, but with more than 10 percent of fibers, the mass is difficult to manipulate. An average rate of 3 percent paper mixed with clay provides good cohesion to the dry and wet (plastic) clay body.

Cohesion of Wet Paper Clay

The presence of fibers in the clay allows it to be spread out in slabs—even 1 mm thick—which can then be shaped. It is possible to make very thin, delicate-shaped pieces, and they will be strong and sturdy after drying. This characteristic of the clay is desirable when making draped pieces and related decorations. But beware: while it is technically possible to make large pieces that are only a few millimeters thick, firing them may cause deformations, even collapse. It is all a question of measurement, experience, and performance of the material!

Cohesion of Dry Paper Clay

With a medium fiber content, the cohesion of dry paper clay is greatly improved compared to traditional clay. Handling, transport, and firing of dry pieces are made easier. Decorative pieces can also be made without firing. But it is in the handling of large dry slabs that the cohesion becomes remarkable: they retain suppleness and flexibility.

Rhythms, Karin Stegmaier, 11.8 x 11.8 in. (30 x 30 cm). Paper fibers provide the cohesion needed for building and dry handling of this delicate stoneware layered piece, with porcelain engobe applied.

Dry porcelain-paper slab with 3 percent fibers (18 x 23.5 in./45 x 60 cm; 0.16 in./4 mm thick).

Hydrophilicity

Distinctive Characteristics

Because of the hydroxyl groups (OH) of the glucose molecules, the fibers have a strong affinity for water while at the same time being insoluble. Water penetrates the wall, then inside the fiber, and makes it swell. The interior volume of the fiber cavity, or lumen (see p. 22), can contain air or water. Exchanges are freely made with the surrounding environment. Combined with the resistance to drying shrinkage and cohesion in the dry state, these water exchanges make it easier to create pieces that can be shaped regardless of their moisture content. The water exchanges can be accelerated if necessary.

Experiment

Increasing amounts of toilet paper fibers are added to 500 g of powdered porcelain and the mixture is brought to a wet consistency for hand-building. The volume and weight of the ball are found to increase more than expected; the amount of water retained by the fibers (around 2–3 g of water per 1 g of paper) is added to the dry paper. Worked in the same way as a non-fibrous clay, a paper clay piece requires less clay and will therefore be less heavy. Paper clay pieces with a high fiber content are particularly light when dry.

The amount of water retained in the clay body also varies according to the type of paper. A highly refined newsprint has a high water absorption capacity, while office paper retains less water due to the presence of mineral fillers.

Clay balls containing respectively 0/15/25/50/100 g of toilet paper added to 500 g of porcelain powder.

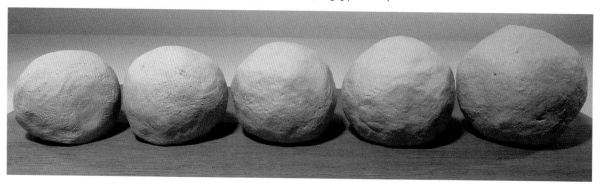

Quantity of water retained per 1 kilo of dry porcelain to form a paper clay for hand-building, by weight of paper added.

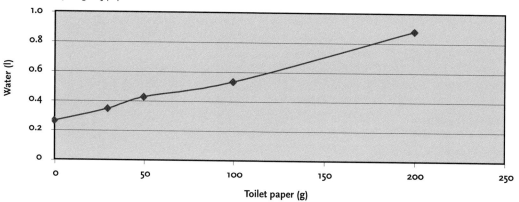

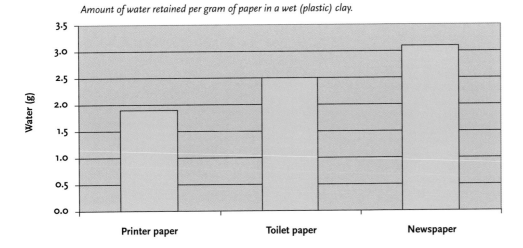

Amount of water retained per gram of paper in a wet (plastic) clay.

Water Exchanges

Solid pieces soften easily on the surface, but not so easily at the center. A 0.2 in. (5 mm) thick paper clay wall will soak up water and soften in a few minutes. The same amount of time is needed to firm up a wall being shaped using a hair dryer or heat gun. Conversely, in a cool, moist atmosphere, water evaporation is slowed considerably.

Let paper clay pieces dry in the open air. Only thin walls and slabs need to be treated with care to keep them from curling.

No Time Constraints

Thanks to the hydrophilicity and cohesion of paper clay, there are no time constraints for working on a piece. It can be completed in one go, quickly firmed up if necessary, or on the contrary, it can be stopped at any time and resumed whatever its consistency. Paper clay works can be built at any moisture level: wet on wet, wet on dry, or dry on dry (see p. 96).

Storing Paper Clay

Shelf Life

Paper clay prepared by hand can be stored for about ten days. Purchased ready to use, it can be stored for six months or even a year if stored in a cool place. Dried, it can be kept for an unlimited period of time.

It is important to know that a mixture of clay, paper, and water is a favorable environment for the development of **micro-organisms**—they are part of the basic life cycles—that can be found everywhere: in the air, in water, on our skin, or on the objects that surround us. Some of them produce enzymes capable of breaking down the cellulose molecules and then use the glucose to grow. This degradation of cellulose is limited to the external chains of the fiber, which remain very robust. It occurs in contact with the air, and you are able to see **molds** appear in the form of white, pink, or black spots. It is slowed by the cold and accelerated when the ambient temperature increases, especially in summer.

These molds do not alter the plastic qualities of the clay and are destroyed during the firing process. It is, however, unpleasant to work with a clay that is not clean and has a sulfurous or musty smell. People who are sensitive to allergens should not use it in this way.

Black stains on a loaf of white stoneware containing fibers.

Blue discoloration of a red paper clay with grog containing 3 percent toilet paper fibers.

A ball of paper clay can also develop blue discolorations in the center while the surface shows nothing. This blue discoloration, less frequent, comes from being enclosed and it disappears upon contact with the air.

To extend the shelf life of paper clay, **bleach** can be added to the paper clay slip at a rate of two tablespoons per liter of slip. Handle it with care; it is irritating to the skin and discolors clothing. Also be sure to work in a well-ventilated area. Bleach will eliminate a large part of the germs present due to the chlorine it contains, but its action will not be permanent. The shelf life of the paper clay will still be affected by the ambient temperature and the presence of air and water. After 1 hour of resting in the open air, the chlorine is eliminated and the slip is then ready to be transformed into a wet clay for hand-building.

Avoid active oxygen-based products such as **hydrogen peroxide**, as some clays contain proteins that accelerate the release of oxygen and cause the slip to foam.

On the other hand, you can use **essential oils** with fungicidal properties, such as thyme thymol essential oil (*thymus vulgaris thymoliferum*), clove (*eugenia caryophyllus*), spike lavender, or oregano essential oil (*origanum compactum*). A few drops are enough for one liter of paper clay slip. Make sure they are well dispersed because they do not mix well with an aqueous mixture. Avoid direct contact with them as they can cause skin irritation when concentrated.

Commercial paper clays contain hypoallergenic preservatives like those used in cosmetics. Effective in very small quantities, they require careful use.

Wet Storage

Wet paper clay will keep better if it is not in contact with the air. The easiest way to do this is to cover the surface with plastic food wrap and place it in a plastic bag or an airtight container to retain the level of moisture. Ideally, the paper clay should be vacuum-packed in a plastic bag. Keep the clay protected in a cool place such as a cellar or, better still, in a refrigerator reserved for this purpose. Freezing is also possible and does not alter the fibers. Be sure to always keep the paper clay away from the light.

Dry Storage

Paper clay keeps perfectly well when dry. Prepare the paper clay as you need it and spread out the rest in slabs about 0.2 in. (5 mm) thick. Dry them and stack them up until you need to use them.

When you want to use this paper clay, cover the whole surface of the slab with water and wait for about thirty minutes. Repeat the operation if more moisture is needed. The paper clay is then ready to be used.

Porcelain slabs stored dry.

Avoid storing paper clay in loaf form as it rehydrates very slowly.

What to Do When Paper Clay Deteriorates

Scrape the surface of the paper clay.

Paper clay that starts to smell bad is developing micro-organisms. Use it quickly or dry it in thin slices. When you're ready to use it, add water and a disinfectant.

If surface stains have formed, mainly in areas not touching the packaging, scrape the surface with a pottery rib to remove them. Before storing the paper clay, carefully place plastic wrap against the surface without any wrinkles to eliminate contact with the air.

Porosity of Pottery

Distinctive Characteristics

The cellulose fibers present in the paper clay burn during the firing process, leaving residues and a network of micropores. This structure remains as long as it doesn't get near the temperature of vitrification of the mass. In practice, this results in porous pottery and a decrease in strength. With a medium fiber content, this porous pottery is frost resistant.

Experiment

Clay and paper clay pottery shards were fired at 1832°F (1000°C) and 2336°F (1280°C), respectively. Weighed, they were then placed in a basin of water for twenty-four hours. Once drained and wiped dry, they were weighed again to determine the increase of their weight and to deduce the quantity of water absorbed. The same procedure carried out after forty-eight hours showed no significant difference.

It is thus observed that, for a given firing temperature, the higher the fiber content, the more porous the clay is. Porosities of porcelain with 3 percent fibers from toilet paper, newspaper, or printer paper are similar.

Paper Residues

Fibers from plants contain cellulose, hemicellulose, and lignin, which are burned up in the firing process, but also various other elements in small quantities such as **mineral substances** that are found as ash at 1832°F (1000°C) and vitrify at 2336°F (1280°C). In some papers there are a significant amount of **mineral fillers** such as kaolin (see p. 24) and they

Water absorption by fired pottery with 0 percent and 3 percent toilet paper.

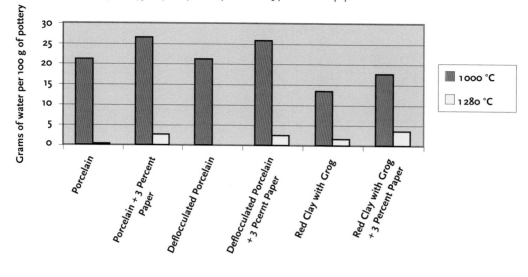

Water absorption by fired porcelain paper clay per amount of newspaper added.

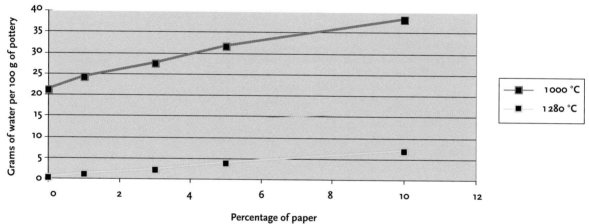

Water absorption by fired commercial paper clay.

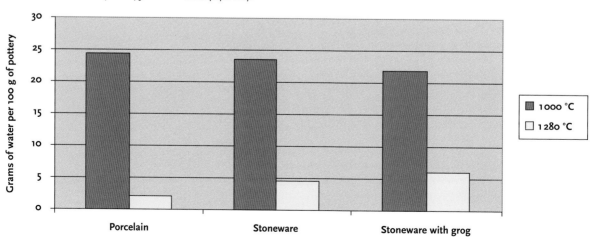

do not burn away. Newsprint leaves a glassy residue; weekly newspapers leave a white, crumbly residue. A sheet of magazine paper can leave more than 25 percent. On the other hand, toilet paper made of pure cellulose wadding leaves very little residue!

These substances influence the maturing of the clay by interaction between the molecules and by changing the melting point. For example, anorthite is formed in a porcelain paper clay containing calcium carbonate at the expense of the usual formation of mullite (crystalline form of alumina silicates ensuring the solidity of the pottery), which delays vitrification.

Heat Exchanges

During firing, the presence of fibers increases the resistance of the clay to thermal shocks. Paper clay is perfectly suited to pit-firing and raku firing (see p. 111). The maximum burning point of paper is around 752°F (400°C), and the cavities of the porous structure absorb the pressure of the steam from the elimination of the clay's water content. The cohesion of the dry paper clay allows it to receive the glaze suspension and, after drying, to be finished by a single firing. A single firing saves a lot of time and energy!

For reproducible results when firing at high temperatures, use papers of identical origin.

Weight and appearance of the residues left after burning (100 g) of the material

Origin of Fibers	At 1832°F (1000°C)		At 2336°F (1280°C)	
	Wt. (g)	Appearance	Wt. (g)	Appearance
Fir wood	0.2	powdery black	0.1	hardened black slivers
Cotton T-shirt	0.2	powdery white	0.2	powdery white
Three-ply toilet paper	0.2	powdery off-white	0.2	vitrified green
Commercial toilet paper	0.7	powdery off-white	0.6	vitrified green
Two-ply toilet paper	1.3	powdery off-white	1.3	firm grey-brown mass
Watercolor paper	5.6	powdery off-white	5.3	powdery off-white
Corrugated cardboard	7.7	crumbly grey-brown wavy sheets	7.5	crumbly grey-brown wavy clusters
Newsprint	10.5	crumbly white flaky clusters	10.2	vitrified, greenish
Office paper	10.5	powdery white and brown	10.4	powdery off-white
Cardboard packaging	13.0	crumbly sheets and white and brown powders	12.8	crumbly sheets and grey-brown powder
Blotting paper	15.0	crumbly sheets and white powder	14.8	powdery off-white
Egg cartons	16.7	crumbly off-white clusters	16.3	grey-brown clusters
Advertising flyers	23.7	crumbly off-white sheets	23.7	crumbly off-white sheets
Magazines	25.4	sheets and off-white powder	25.0	brittle greenish white sheets
Brochure (glossy paper)	26.4	powdery white	25.9	powdery white
Weekly papers	28.7	crumbly sheets, white and colored	28.6	crumbly sheets, white and colored

Hollow Structures

With a traditional clay, a hole must be drilled in the wall of a piece with a hollow interior volume to avoid bursting during firing. The porosity of a paper clay makes this precaution unnecessary. However, be careful with thick walls of clay with a low paper content; they will not withstand the pressure as their porosity is not high enough.

How to Improve Porosity

For all **decorative pieces**, porosity makes the pieces lighter and easier to fire. On the other hand, porosity is an inconvenience for **containers** or **utilitarian ceramics**. For these pieces, use only paper clay with 1 percent or 2 percent fibers and increase the firing temperature by 20 to 40°F (10 or 20°C), or even more if the deformation of the pottery remains acceptable. Another solution to continue firing at the usual temperature is to use a mixture that includes a clay with a lower maturation temperature.

The application of a **glaze on greenware or bisqueware**, in addition to being decorative, makes a piece more waterproof and easier to care for. Make sure that the glaze matches the clay, meaning that their coefficients of expansion are close. If crazing occurs, the container will no longer be waterproof.

For **unglazed pieces**, polishing and the application of fine particles of an engobe of terra sigillata can close the surface pores. A thorough smoke firing acts in the same way and makes the pieces watertight.

Density

If the wall is highly porous, in the case of paper clay with a high percentage of paper, cover the coil with a film of cooking oil.

Distinctive Characteristics

Each gram of defibered paper retains 2 to 3 g of water in a wet/plastic paper clay. Hydrophilicity (see p. 36) causes a very pronounced water retention in clays with a high fiber content. The consequence is a decrease in the density of the paper clay, which contains more water and less clay for the same volume.

As it dries, the density continues to decrease due to the loss of water. Once the fibers are burned up, it decreases again. It is only when approaching the melting temperature that the clay regains its usual density.

Experiment

Measuring the density of the clay, that is to say its weight in relation to the weight of an equivalent volume of water, requires a precision balance and a 100 ml foot cylinder. A wet/plastic clay is shaped into short 50 g coils, with a diameter slightly smaller than the opening of the foot cylinder.

An initial volume of 50 ml of water is used to immerse the weighed clay coil and to determine its volume by displacement of the water level. The wet clay and the dry clay are immersed and removed quickly.

Weight and Strength of the Pieces

A ceramicist taking his or her first paper clay pieces out of the kiln is surprised by their **light weight**. One of the reasons for this, as we have said, is that the presence of the fibers and the water they retain has reduced the quantity of clay. The lightening is noticeable at high fiber concentrations. However, the most common paper content is only a few percent, which is not enough to explain this lightness. The main reason is that the cohesion of paper clay allows for much thinner walls than with non-fiber clay.

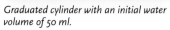

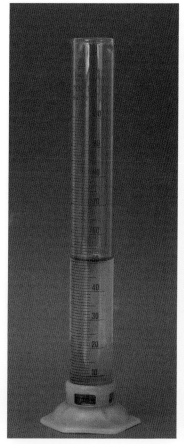

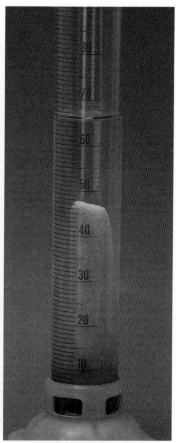

Measuring the weight of a short paper clay coil after firing at 1832°F (1000°C).

Graduated cylinder with an initial water volume of 50 ml.

Measuring the increase in volume with the paper clay coil.

Comparison of some densities

	Wet/Plastic Clay	Dry Clay	1832°F (1000°C)	2336°F (1280°C)
Porcelain with no fibers	1.84	1.79	1.61	2.35
Porcelain-paper with 1 percent toilet paper	1.79	1.73	1.54	2.27
Porcelain-paper with 3 percent toilet paper	1.76	1.69	1.49	2.19
Porcelain-paper with 5 percent toilet paper	1.71	1.66	1.40	2.11
Porcelain-paper with 10 percent toilet paper	1.64	1.57	1.29	1.93
Porcelain-paper with 10 percent newsprint	1.58	1.42	1.19	1.96
Commercial porcelain-paper	1.79	1.75	1.58	2.28
Commercial stoneware-paper	1.87	1.88	1.66	2.15
Commercial stoneware-paper with grog	1.85	1.88	1.67	2.13

Although weight is no longer a handicap for the **construction of very large pieces**, the **risk of sagging** during firing must be taken into account. The height and thickness of the pieces must take into account the weight of the whole piece. A high fiber content also reduces the **strength** of the pieces after firing.

On the other hand, the very good cohesion of dry paper clay opens a scope of application for large pieces and wall installations.

Loss in weight of 100 g of a wet porcelain clay containing toilet paper fibers.

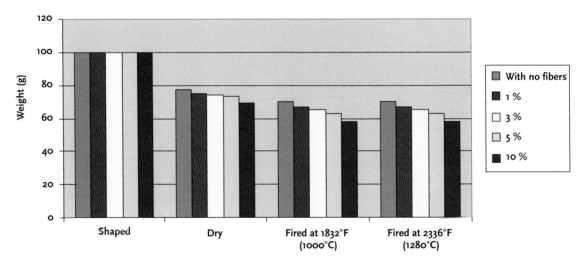

Loss in volume of 100 g of wet porcelain clay containing toilet paper fibers.

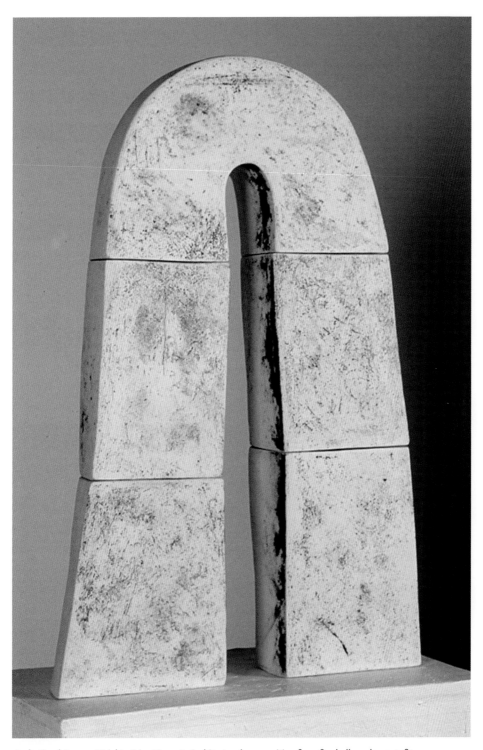

Arch, *Carol Farrow. Height 26 in. (67 cm). Architectural composition from five hollow elements fit together. The reduction in wall thickness thanks to the addition of fibers makes the arch very light.*

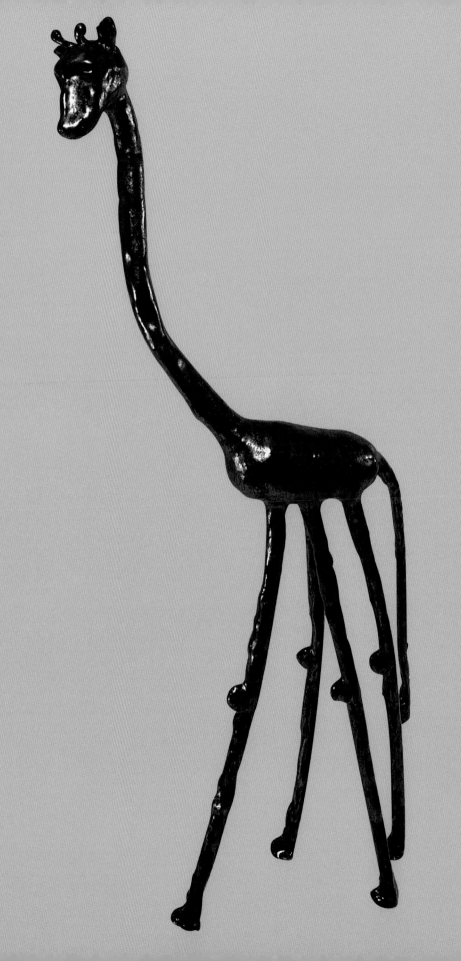

How to Make Paper Clay

Basic Recipe for Making Paper Clay

By making your own paper clay, you can use the clay of your choice and adapt the fiber content to your intended use (see p. 54). Prepare it in small quantities, as you need it.

The principle. This procedure introduces a lot of water, which is then removed. The advantage is that it guarantees a homogeneous mixture of the clay slip and the paper pulp. The pulp is drained and then added to the clay slip to form a paper clay slip. The latter is poured onto an absorbent surface.

Commercial paper clays

Ready-to-use paper clays come in 5 or 10 kg loaves from suppliers of ceramic products. They are available in various types of clay with different colors and maturation temperatures: porcelain, white stoneware, or white or red earthenware. Clay with grog is suitable for large pieces that will then be less prone to deformation during firing. These paper clays contain an average fiber content of about 3 percent. They cost about 50 percent more than traditional clays.

Materials

Three Containers
The first is used to prepare the clay slip, the second to defiber the paper, which is then drained using the third container to recover the pulp. Depending on the quantities to be prepared, use large bowls, pails, or trash cans.

From Kitchen Whisk to Professional Blender
The energy required to break up the fibers varies depending on the type and amount of paper.

A kitchen whisk can only defiber toilet paper. A **household immersion blender** is suitable for preparations up to 3 liters. With a stand mixer, the mixture may need to be divided into portions

Choice of containers for preparing paper clay.

Different mixing tools for making paper clay.

to fit the volume of the bowl. Models with variable speeds allow you to gradually increase the power. If your blender struggles, dilute the pulp before continuing.

A slip blender or a paint mixer attached to a drill will be more suitable for repeated use. Either of these tools is long enough to be able to mix volumes of 10 to 15 liters. Be sure that the container is large enough, as the use of these tools will raise the level of the mixture.

A **professional immersion blender** is designed for catering kitchens. Ceramicists have adopted it as it is very robust and will create a smooth, homogeneous slip and can be used to prepare glazes. A model with medium power allows you to quickly prepare paper clay in a large container. It is the ideal tool for preparing a large quantity of paper clay.

Strainer or Sieve

Choose a kitchen strainer or a tight-mesh sieve to drain the pulp as best as possible. Any perforated container will do, as long as it is lined with a cloth that will allow water to pass through it while retaining the fibers.

Household strainer and flour sieve.

Plaster Surface

Plaster tile sitting on laths.

Plaster will absorb the excess water from the paper clay slip and transform it into a paper clay for hand-building. The easiest way to do this is to buy a 20 x 25.5 in. (50 x 65 cm), 2.75 in. (7 cm) thick **plaster tile**—intended for interlocking partitions—from a building supply store. Choose it in traditional plaster without waterproof treatment. You can make a similar surface by pouring plaster into a wooden frame.

Make sure the plaster tile is lying level on two laths or other narrow wood strips to ensure ventilation from below for the removal of moisture. Be careful not to damage the surface of the tile and never use metal tools. If you are preparing large quantities, multiply the plaster tiles as needed.

Clay Slip

For a little more than 3 kg of a medium-fiber paper clay:
3 kg of wet/plastic clay, with or without grog
1 clay cutting wire
1 board
1 pail
1 wooden roller or hammer
2 liters water
1 kitchen whisk

Clay mixed with water forms a slip. At the wet/plastic stage, water penetrates into the clay body very slowly. On the other hand, a completely dry and crushed clay absorbs water quickly. It is essential to wear a mask when handling dry clay.

1 Cut the clay into very thin slices with the wire. Place the slices on a wooden board and let them dry for a few days in the open air.

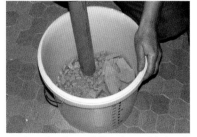

2 When the clay is dull and crumbly, break it up into a bucket and crush it with a roller.

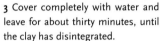

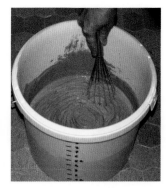

4 Whisk until the mixture is perfectly homogeneous and forms a smooth, creamy slip. You will obtain about 3 liters of slip.

3 Cover completely with water and leave for about thirty minutes, until the clay has disintegrated.

Always give the clay time to soak up the water before starting to mix. If the clay is not completely dry before adding water, if it is very fine, or if it is prepared with deflocculant, the platelets will not separate easily. The whisk does not provide enough energy, and it is necessary to use an immersion blender to make it a smooth, uniform consistency.

Good to know: Making paper clay is a good opportunity to recycle unfinished traditional clay pieces, broken raw pieces, or dried pieces of clay lying around in a studio! Thorough drying and crushing are essential before adding water. To obtain 3 kg of paper clay, you will need about 2.2 kg of dry clay.

Using powdered clays

These clays are usually used to make casting slip. Pour the powder into the water so that it soaks in easily. If you must pour water over the powder, let it run down the side of the container to avoid introducing air into the mass. If the clay powder contains deflocculant, reduce the amount of water added by half and take this into account when measuring the fiber content by volume.

Porcelain powder to be mixed with water.

Paper Pulp

If you have a pulp mill or paper mill near you, try to buy pulp directly from it. If not, collect waste paper to prepare the pulp. Your tools will have to be adapted to the volume to be prepared as well as to the paper.

Take the process in steps. Tear the paper into pieces of a few centimeters or use paper from a shredder, then leave it to soak in a large volume of hot water (1 liter of water for 10 to 20 grams of paper). Let it soften for at least twenty-four hours before mixing it with a suitable tool.

If you don't have power tools to vigorously blend the paper and water mixture, or if you don't have enough time, prepare your paper pulp with toilet paper.

If the pulp contains clumps, the paper is not completely broken down. Let it sit longer and mix again. All papers, except toilet paper, require vigorous blending. A large volume of water or hot water will in all cases facilitate the separation of the fibers.

Supplies:
1 roll of toilet paper (about 70 g or 2.5 oz.)
1 pail of water
1 kitchen whisk

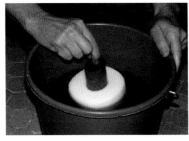

1 Fill a pail with water and place a roll of toilet paper in it. When the paper has swollen, remove the cardboard tube.

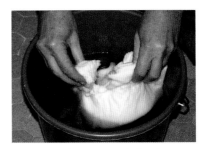

2 Pull apart the wet paper by hand.

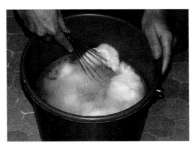

3 Mix until homogeneous with a kitchen whisk.

4 The paper pulp is ready when it is fleecy and the mixture is uniform.

Which tool to use for which paper?

	Kitchen Whisk	Immersion Blender	Mixer or Blender	Professional Immersion Blender
Pure cellulose wadding toilet paper	X	X	X	X
Cheap toilet paper	X	X	X	X
Newspaper		X	X	X
Office paper		X	X	X
Weekly paper		X	X	X
Advertising flyer		X	X	X
Magazine, glossy brochure				X
Egg carton				X
Corrugated cardboard				X
Cardboard packaging				X

Paper Clay Slip

Once the clay slip and the paper pulp are ready, you will be able to recover the fibers and start mixing to obtain the paper clay slip. This is both quick and easy to do.

Supplies:
1 pail
1 fine mesh strainer
1 kitchen whisk

 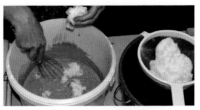 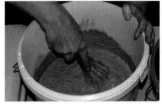

1 Pour the paper pulp into a fine kitchen strainer placed on a pail: the water will drain out by itself.

2 Pick up the pulp by handfuls, squeezing it somewhat, and add it to the clay slip.

3 Mix vigorously with the whisk: you will get about 4 liters of paper clay slip, a bit lumpy.

To avoid fiber clumps in the paper clay slip, make sure the pulp is homogeneous and do not press the pulp too hard before adding it to the slip. Fiber clumps are uncoated fibers that cause splintering during firing; a blender will get rid of them. At this concentration, a paper clay slip is a bit lumpy, and the effect increases as the concentration increases. With an equal weight of paper, paper clay slip containing newspaper is smoother than that prepared with toilet paper.

Tip

When preparing the paper clay, reserve some of the paper clay slip for later if needed for joining and smoothing. You will also find recipes for quick slip preparation on page 104.

Paper Clay

A large part of the water used during preparation must be removed to give the paper clay slip a wet/plastic consistency. This step is not particularly difficult, but it may take from thirty minutes if the plaster is quite dry to a few hours if it is wet.

Supplies:
1 plaster tile
1 plastic card

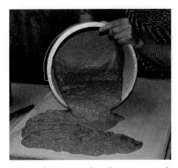

1 Pour the paper clay slip just mixed onto the plaster tile.

2 Spread out and level the surface with a plastic card.

3 Wait until the surface of the clay dulls completely and is no longer sticky. Loosen a side of the paper clay slab with the plastic card.

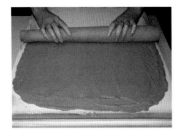

4 Roll up the slab.

5 Fold the roll over and knead the paper clay.

6 The paper clay loaf is ready to be shaped.

If the paper clay sticks to your fingers, it is because your paper clay contains too much water to be worked and should be left to dry a little in the open air. Preparing paper clay bodies one after the other will end up saturating the plaster with water and will lengthen the preparation time. It is therefore advisable to space out the use of the same tile to let the moisture level drop.

> ### Tip
>
> For a first attempt, if you don't have a plaster tile, make a mat from five newspapers unfolded and placed on top of each other, or from an old sheet folded up. Allow twenty-four hours for the excess water to drain away.

Fiber Content of Paper Clay

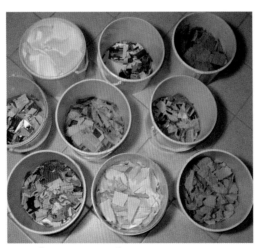

100 g of torn papers per pail.

Ordinary paper is made of a mixture of short and long fibers, the proportion of which varies depending on the paper. The cellulose content depends on the pulp used to make the paper (see page 20). However, the properties of the fibers are similar. Access to resources and the material available will guide your choice. The amount of paper added to the clay must be customized to fit the shaping technique.

With practice, you will be able to see which type of paper you prefer and adjust the concentration as best as possible. Long fibers, for example, bring more cohesion to the paper clay, but do not make it easier to cut, scrape a surface, or throw.

The color of the pulp obtained from different papers varies. Drained for a long time or pressed somewhat, the fibers in the pulp retain about ten times their weight in water. The volume of dry torn paper varies greatly, but the volume of the pulp is similar.

A **low content (1 percent to 2 percent)** of paper fibers in a clay body is hardly noticeable. It allows all traditional ceramic techniques, but the inherent properties of paper clay will not be fully available. Resistance to drying shrinkage is still low; cohesion of the wet clay and the dry clay is average. With 1 percent fibers, the porosity of the pottery is not affected

and containers do not pose sealing problems. But be careful, as air bubbles, residual moisture, and thermal shock can cause a piece to explode during firing, just as if it contained no fibers!

A **medium content (3 percent to 4 percent)** of paper fibers in a clay opens up new possibilities due to a reduction in drying shrinkage. It is easier to shape. These paper clays are resistant to thermal shock from firing. Their cohesion in the dry state is good, and the pieces can be handled without any problem. At the same firing temperature, they are porous and less solid than those made of the same clay without fibers. These paper clays are the ones most commonly used. Paper clay slip with a medium fiber content is also best suited for repairs on traditional clay or paper clay.

A **high fiber content (5 percent or more)** makes a wet clay difficult to work with, as its plasticity is reduced and the fibers become very noticeable. However, if you want to make large pieces, for which weight is an important factor, this will reduce their weight as the density of the paper clay is less. The risk of cracking during the drying of pieces with a high fiber content is low, which makes it possible to combine and mix various materials. Their cohesion in the dry state is very good. At the same firing temperature, they are less resistant, the porosity of the pottery going hand in hand with its friability.

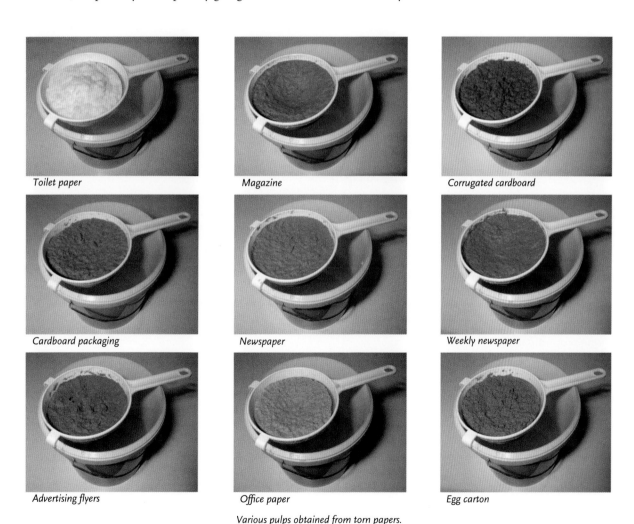

Toilet paper

Magazine

Corrugated cardboard

Cardboard packaging

Newspaper

Weekly newspaper

Advertising flyers

Office paper

Egg carton

Various pulps obtained from torn papers.

Paper clay uses by fiber content

Technique \ Content	Low (1–2 percent)	Medium (3–4 percent)	High (5 percent or more)
Pinching	+	++	+
Coils	+	+	
Thin coils	+	++	
Slabs	+	++	+
Draping	+	++	
Throwing	+		
Supports	+	++	++
Armature		+	++
Casting	+		
Dipping		++	
Covering		+	++
Embedding, inclusions		++	++
Brushing on plaster	++	++	
Repairing		++	

+ = Suitable ++ = Particularly suitable

Preparation by Weight

The most accurate method for measuring clay and fibers is to weigh the dry clay and paper before starting to make it. This way a mixture can be reproduced by using consistent batches of the same type of paper. Electronic scales with tare memory are very practical. Here are the steps to follow for a 3 percent paper clay.

1 Weigh 1 kg of dry or powdered clay and prepare a clay slip with 1 liter of water.
2 Weigh 30 g of paper, add a few liters of water, and prepare paper pulp.
3 Add the drained paper pulp to the clay slip. Mix the paper clay slip until smooth and uniform.
4 Pour the paper clay slip onto a plaster tile and leave it until the desired consistency is reached.

Some proportions

Wet Clay	Dry Clay	Paper	Ratio of Paper/Dry Clay	Water			Weight of Resulting Wet Clay Body
				In Clay Slip	In Pulp	In Paper Clay Slip	
1,300 g	1,000 g	10 g	1%	10 dl	1 dl	11 dl	1,340 g
1,300 g	1,000 g	20 g	2%	10 dl	2 dl	12 dl	1,380 g
1,300 g	1,000 g	30 g	3%	10 dl	3 dl	13 dl	1,420 g
1,300 g	1,000 g	50 g	5%	10 dl	5 dl	15 dl	1,500 g
1,300 g	1,000 g	100 g	10%	10 dl	10 dl	20 dl	1,700 g

Preparation by Volume

The fiber content can be measured when mixing the pulp and the slip. The method is easy, but not very precise when it comes to passing on a recipe. Indeed, mixing "1 part pulp to 3 parts slip" does not take into account the dilution, meaning the actual weight of paper and clay contained in the water. Using the same container, measure out the different volumes in the desired proportions and mix. You can also measure the increased volume of slip from adding the pulp by using a graduated pail or by inserting a ruler.

Making a graduated measuring pail

If you don't have a large graduated measuring container, make one using a clear pail. Pour water into it, liter by liter. On the outside of the bucket, use a permanent marker to mark the level of each liter added. This bucket will be used to prepare the slip, then the paper clay slip.

1 Add water to dry clay to make a smooth, creamy slip.
2 Add a large volume of water to paper torn into pieces to prepare paper pulp.
3 Note the volume of the slip and add drained paper pulp until the desired volume (see equivalence table).
4 Pour the paper clay slip onto a plaster tile and let it stand until the desired consistency is reached.

Creamy clay slip (6 liters).

Paper clay slip with 10 percent pulp by volume (6.6 liters).

Paper clay slip with 30 percent pulp by volume (7.8 liters).

Paper clay slip with 50 percent pulp by volume (9 liters).

Some equivalences of preparations by weight and volume (approximate values)

Fiber Content	Weight of Paper Added in Relation to Weight of Dry Clay	Increase in Volume of the Slip from Adding Pulp
Low	1–2%	10–20%
Medium	3–4%	30–40%
High	5–10%	50–100%

Advanced Preparation

Once you have become proficient in making paper clay, it is possible to prepare the whole mixture in one container with only the quantity of water required for the paper clay slip (see proportion table). A powerful mixer becomes essential to properly defibrate the paper and make sure the paper clay slip is homogeneous. Weighing is necessary to know the proportions of the mixture.

Incorporating fibers into the clay by manual kneading is a bit tricky as the fibers tend to form clumps that cause a piece to explode when firing. If you have an extruder or kneading machine, it will be much easier to prepare the paper clay. Simply add the fibers in pulp form to the raw materials that make up the clay body or wet/plastic clay.

This quick preparation requires little water but a very powerful blender. It is not recommended for beginners.

1 Place 60 g of newspaper torn into small pieces into a large container. Add 2.6 liters of very hot water.

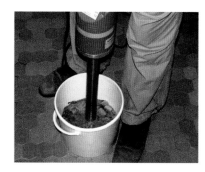

2 Let the newspaper soak up the water. Mix until it forms a gray homogeneous puree.

3 Add 2 kg of porcelain powder.

4 Mix until the paper clay slip is smooth and uniform.

Tip

By using toilet paper, the volume of water can be reduced and a simple whisk can be used to prepare a thick paper clay slip. Let the water soak into the porcelain powder before starting to stir the mixture.

5 The paper clay slip is ready to be turned into paper clay with 3 percent fibers.

Consistencies of Paper Clay

The consistency of the paper clay is very important when working on a project. It is often necessary to join or attach parts, fill in indents, or reinforce an area. If you have wet paper clay, soft paper clay, and paper clay slip available, this is the optimum situation for building ceramic pieces. Be sure to always moisten a dry wall.

Changing the consistency of 1 kilo of wet/plastic paper clay with a medium fiber content

Appearance	Name in This Manual	Characteristics	Amount of Water to Add	Use
	Wet/plastic paper clay	Does not stick to the fingers Does not crack when building with it	None	Hand-building: Traditional techniques Throwing Covering armatures Inclusions Embedding Covering of supports
	Soft paper clay	Tends to stick to fingers	1 dl (3.4 oz.)	Joining parts Filling in cracks
	Very soft paper clay	Sticks on fingers	2 dl (6.75 oz.)	Evening out surfaces Adhesion to wire mesh with openings Brushing
	Thick paper clay slip	Stays stuck on fingers	4 dl (13.5 oz.)	Dipping Filling cracks Covering paper or gauze on wire mesh Brushing
	Paper clay slip	Does not hold its shape	6 dl (20.25 oz.)	Joining pieces onto raw, dry, or bisque surfaces Repairing small cracks Smoothing uneven surfaces
	Liquid paper clay slip	Liquid	10 dl (33.8 oz.)	Slip casting (less dilution when adding deflocculant)

If you are using a medium-fiber dry paper clay,
increase the amount of water to be added by 4 dl (13.5 oz).

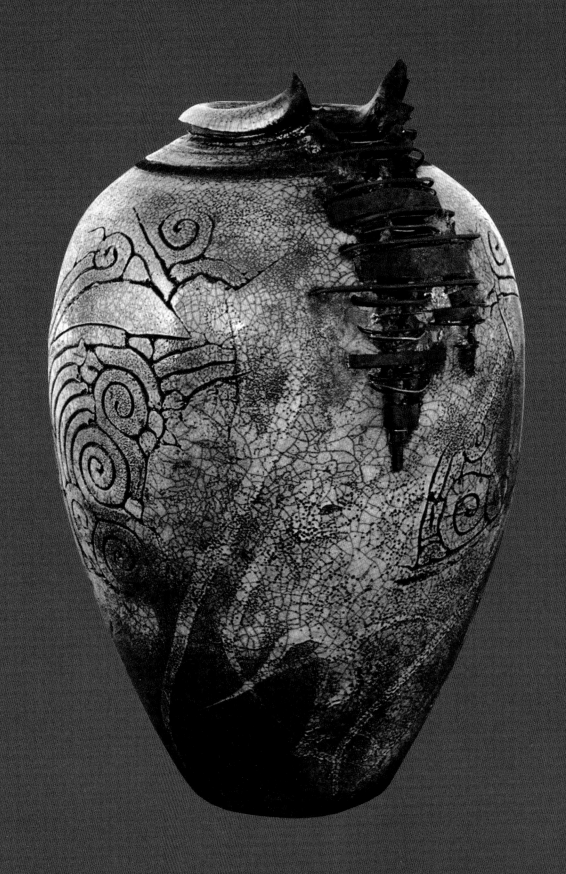

How to Use Paper Clay

For ceramicists and designers from all walks of life, paper clay opens a wide field of applications. It can be shaped like a traditional clay. The very good cohesion of dry paper clay makes it possible to create decorative objects without the need for a kiln or firing, which also makes occasional workshops easier. It is perfectly suited for beginners and for children as the fiber content makes it easier to correct many blunders! The creations are recyclable, as moistened paper clay is reusable.

The addition of fibers frees artists from most of the technical constraints of traditional clay, allowing them to learn and explore new ways to shape pieces, both playful and creative and without worrying about cracks appearing during drying, as they are limited and can be easily repaired. The ceramicist can sculpt by playing at times with the forced firming up of a wall, and at times with softening it to alter a part that has dried. The assembling of various parts can be done equally as well in either a wet or a dry state or by combining all degrees of wetness and thickness. The weight of the pieces is greatly reduced when the fiber content is high.

In a traditional pottery studio and for anyone sculpting or throwing clay without fiber, paper clay slip is an excellent adhesive for sealing cracks and repairing broken pieces. When a piece in progress inadvertently dries out, it is also possible to continue working on it by adding fibers to the traditional clay.

Pinch Building

Pinch building is simply using the pressure of your fingers to shape a piece of clay. A medium fiber content means the paper clay is versatile and particularly well suited for normal hand-building and group workshops. It makes it possible to progress rapidly through the work for large pieces, mixing steps of firming, modifying, and adding. A high fiber content makes bulky pieces lighter.

Traditional Pinch Building

Carve, press, pinch, pierce, hollow, and shape paper clay as you wish! The firmer it is, the harder you press and the better it stays in shape.

Wet your fingers to erase cracks and smooth them out. Joining parts requires paper clay slip unless you are working with a fairly soft paper clay, which will bond to the existing mass by pressing and smoothing. Use sculpting tools or push away and remove unwanted clay with your fingers. You can create walls of varying thicknesses, as the presence of fibers

Alésia, Nina Seita. Height 15.75 in. (40 cm). Solid paper clay sculpture. Raku firing.

balances the stresses of shrinkage as it dries. Moreover, there is no need to hollow out the pieces. Once dry, they can be fired solid without risk (see p. 42).

1 Press down into the middle of a ball of paper clay with your thumb and fingers to open it up.

2 Pinch the clay to stretch it.

3 Thin it out, bend it, and lengthen the wall by pressing it with your fingers.

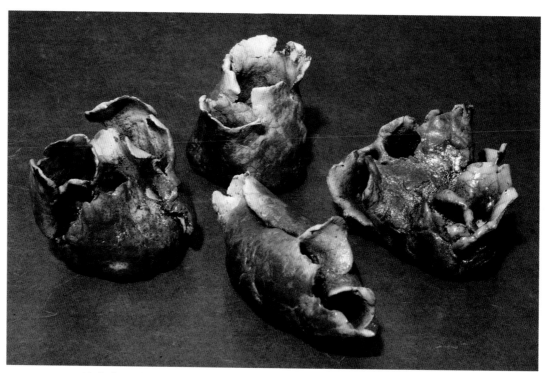

Pinched, stretched, and hollowed sculptures. Raku firing.

Drying in Stages

To sculpt without having to plan in advance, and to ensure that a piece is well supported, firm it up as you go with a hair dryer or heat gun. Partially dry the paper clay to make sure that areas that are weight bearing or that are not free-standing are supported. A sculpture can thus have a moisture content that increases going from the bottom to the top.

Thin walls and willowy shapes become possible due to the good cohesion in the dry state. But be careful: If you want to fire the piece, reinforce the base to avoid sagging. Choose a paper clay with grog for large pieces intended for firing.

Paper clay loses water quickly under the action of hot air.

1 Press the paper clay between your fingers to shape it.

2 Firm the piece with a hair dryer to prevent it from bending under its own weight and then continue shaping.

3 Turn the finished piece over and moisten the thin parts.

4 Apply paper clay slip to the moistened areas.

5 Reinforce the base with paper clay.

Creating Separate Elements

Shapes mounted on legs (giraffe, chair, etc.) or composed of separate sculpted pieces (characters on a bench, circle of children, etc.) can be worked separately. Once firmed up, the elements are joined together. If they are still wet, apply a thick layer of paper clay slip and then assemble. If the individual parts are dry, moisten the surfaces to be joined and apply paper clay slip. Score the areas to be joined beforehand to ensure good adhesion. The presence of fibers also makes it possible to join wet elements to dry elements, following these same steps.

Small surface cracks often appear during drying. Moisten and brush them with liquid paper clay slip, then smooth with a finger.

The following step-by-step guide shows the making of a stoneware pedestal table.

Pinch built glazed earthenware. Sylvie Hug.

1 Shape the different elements of the pedestal table using paper clay with grog.

2 Fray the outside edges of the legs and the top, then let air dry.

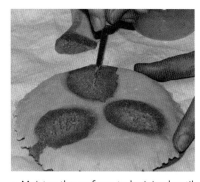

3 Moisten the surfaces to be joined until they can be scored with a knife.

Glazed stoneware pedestal table.

4 Generously coat the surfaces to be joined with paper clay slip.

5 Place the legs, spread on some slip, and reinforce the joins with soft paper clay.

Delicate Sculpting

Paper clay makes it possible to do some very delicate sculpting. A fiber content of 2 percent to 4 percent will ensure cohesion when wet or dry. If the paper clay cracks around the edges, work with wet fingers (dipping them often in water). Adhere the delicate elements together by moistening their points of contact. Attach them to a larger clay piece with paper clay slip.

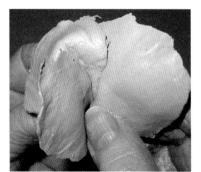

1 Flatten the paper clay to form petals and press them together at their bases moistened with water.

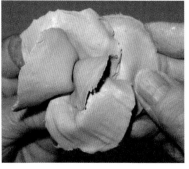

2 Form the flower, giving a curve to the petals.

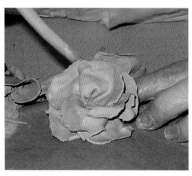

3 Attach the flowers one by one to the firmed clay base using paper clay slip, pressing with a modeling tool.

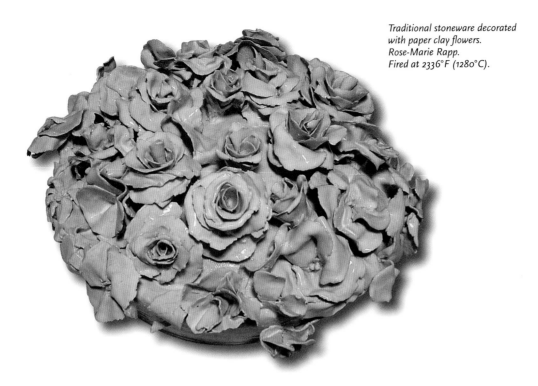

*Traditional stoneware decorated
with paper clay flowers.
Rose-Marie Rapp.
Fired at 2336°F (1280°C).*

Paper clay makes it easy, for example, to arrange flowers on a traditional clay base, or a paper clay base, without worrying about drying, handling, or spacing out the various steps—but methods for joining must be followed (see p. 96).

Coil Construction

Constructing pieces using coils is a universal technique that has been practiced for thousands of years throughout the world. The walls of vases or large jars can be formed from a stack of clay coils stuck together. Coils can also be used to build up the rough outline of a bust around an empty space. There are no particular advantages to using paper clay in the traditional building of a coil piece. However, it does offer the possibility of creating a piece by simply stacking thin decorative coils. Avoid paper clays with a high fiber content and choose ones with grog added when assembling pieces conventionally.

Making Coils

Start by squeezing and rotating a small quantity of paper clay in your hands to form a short, even log shape. Then place it on the table or on a plastic tablecloth and roll it back and forth in complete rotations. If the paper clay sticks to your fingers or to the table, it is too soft. Leave it in the air to firm up, or knead it on a plaster surface to quickly absorb the excess water. If, on the other hand, the coils crack, the clay needs water, so wet your fingers regularly while working. If the problem persists, use a less fibrous paper clay.

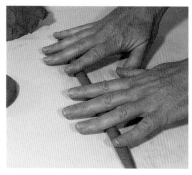

1 Roll a log of paper clay back and forth with a wide, sweeping movement. Apply moderate pressure to form a coil of even thickness.

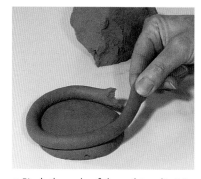

2 Pinch the ends of the coil to adjust its length. It is placed here on the base of a pot made from a small, flattened ball.

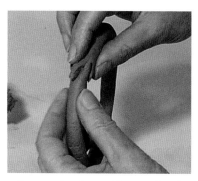

3 Form a ring by pushing on the clay with your fingers to firmly join the ends together.

Simplified Assembly

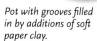

Dish made from coils joined end to end and rolled in a spiral.

This simplified version of building with coils is especially for beginners. The coils are stacked, which makes it easier to see any uneven parts as well as how the shape changes with the length of the coils. To create an outward curve, make the coils longer and place each coil slightly to the outside edge of the previous one. Conversely, to curve back inward, place shorter and shorter coils along the interior edge.

If you simply place the coils one on top of the other without pressing, the piece can be taken apart and modified. To ensure that the coils will adhere to one another, coat the finished piece with paper clay slip or wet the surface of the coils when assembling.

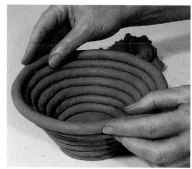

1 Place the coils one on top of the other.

Pot with grooves filled in by additions of soft paper clay.

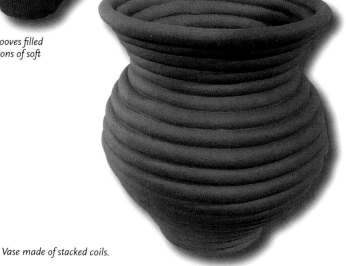

Vase made of stacked coils.

2 Using a brush, coat the grooves with paper clay slip.

Traditional Assembly

Each coil is "welded" to the previous one by pressing on the clay. Avoid firm paper clay as the coils should be joined easily by pressure of the fingers. With a low or medium fiber content paper clay, the addition of a high proportion of grog restores the direct, firm contact needed when building large pieces. If your piece becomes deformed or sags while assembling it, use a hair dryer or let it air dry to firm up before continuing. Using a banding wheel makes assembly easier and allows you to work in one spot with equal pressure as the pot rotates from the momentum of turning it by hand. Smooth the wall as you go with a rib or a plastic card.

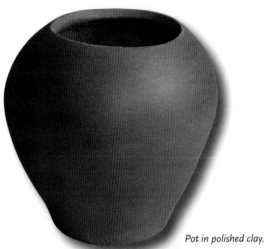

Pot in polished clay.

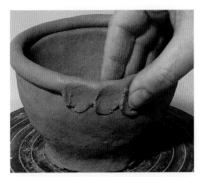

The coils are welded on the outside.

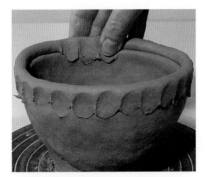

The coils are welded on the inside.

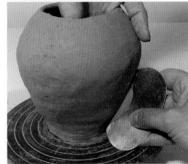

Smoothing with a rib.

Decorative Coils

A paper-clay coil, when rolled for a long time, gets longer and thinner. To keep its plasticity, it is necessary to use a paper clay without grog, with a fiber content of 2 percent to 4 percent. Choose one that is a little soft and work on a non-absorbent surface, as with this technique the paper clay dries quickly.

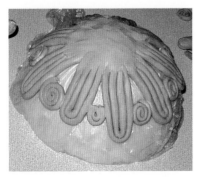

Shaping of a small bowl with coils wound and assembled using paper clay slip.

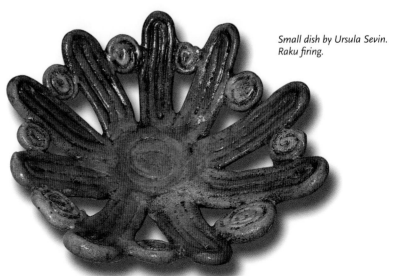

Small dish by Ursula Sevin. Raku firing.

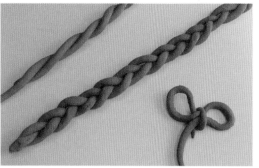

Twisted, braided, and knotted coils.

Coils can then be braided, woven, or even knotted. Before shaping, wet the surface to avoid cracking. Use the coils to form the wall of a piece or as decorative elements. Apply paper clay slip before attaching to a wet wall. If the wall is made from non-fiber clay, score first to ensure good adhesion.

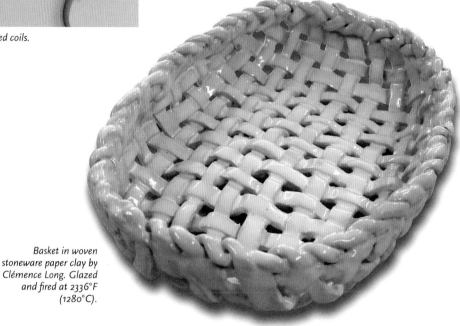

Basket in woven stoneware paper clay by Clémence Long. Glazed and fired at 2336°F (1280°C).

Slab Technique

The easiest way to create a slab is to slap a ball of clay on a table and hit it with your fist. A rolling pin or a slab roller (a specific piece of equipment) must be used to achieve an **even thickness**. The slabs to be assembled can then be cut and shaped.

When using **traditional clay**, they must be assembled when leather hard (i.e., when they are still wet yet firm). They must be assembled very carefully to avoid cracking during drying and firing. The contact surfaces are scored and then brushed with slip before being pressed together and reinforced in the interior seams with a clay coil. **Paper clay** is particularly well suited to slab construction. A medium fiber content allows for a new and less restrictive approach to shaping. Large slabs a few millimeters thick can be handled both wet and dry. A simple application of paper clay slip, followed by finger pressure on the softened edges, is sufficient to assemble the slabs. Moreover, the shape of a firmed paper clay slab is not final. Water, paper clay slip, or soft paper clay can be used to modify the curvature and affix added elements. Water can be removed just as easily by heat or air circulation. A piece can be made in one go or put on hold.

Rolling Out Slabs

Use a rolling pin to roll out a wet or plastic paper clay directly on a table with a non-absorbent surface, such as laminate or melamine. If the clay sticks to the table, use a square of cloth (linen, cotton, jute, etc.) or an absorbent wooden board (natural wood, chipboard, plywood, etc.). If it sticks to your fingers or to the roller, the water content is too high. Expose it to the air so that the excess water evaporates.

If the edges of the slab develop little cracks when rolled, wet them with water. If larger cracks appear, the moisture content of the paper clay is too low or the fiber content is too high.

> For precise work, use as guides two laths of the same thickness as the desired thickness of the slab.

1 Place a ball of kneaded paper clay on a linen cloth and hit it with your hand or a rolling pin to flatten it.

2 Place a lath on each side of the clay pancake and spread it with the roller from the middle outward.

3 Lift the slab after the roller has passed over it to loosen it from the cloth. Rotate it 90 degrees.

4 Repeat these steps until the slab no longer moves when the rolling pin goes over it.

Pouring Slabs

It is very simple to prepare somewhat thin, large slabs with paper clay slip. To do this, place two identical laths on a plaster surface. They will determine the thickness of the slab (when drying, it will decrease from 20 percent to 50 percent depending on the water content of the paper clay slip). Pour the slip into this template, then level the surface with a third lath.

The slab must be taken off the plaster as soon as it has firmed up, either to use it or to accelerate its drying.

The upper surface of a cast slab has an uneven appearance. Not very pronounced at low concentration, this granularity increases with the percentage of fibers. If you prefer

smooth surfaces, simply turn the slab over. The granularity varies, at identical concentration, depending on the paper used. A paper clay slab with 3 percent fiber content will be smoother with newsprint than with pure cellulose wadding toilet paper.

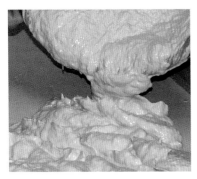

1 Pour and spread the paper clay slip onto a plaster tile between two laths of equal thickness.

2 Immediately level the surface by sliding a third lath over the other two.

3 When the surface of the slab has dulled and the slip has reached wet/plastic consistency, peel up the edges of the slab with a rubber rib or a plastic card.

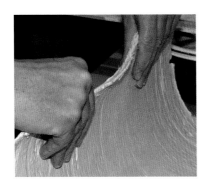

4 Gently lift the slab to detach it from the plaster.

5 Place the paper clay slab on the plaster or on a dry absorbent surface. Allow it to firm up further or dry completely.

Plaster Surface

The absorption rate of a plaster surface varies with the hardness of the plaster and its water content. It decreases with repeated use and increases with infrequent use. New or perfectly dry plaster is very absorbent. Avoid pouring a thin slab on such a plaster tile as the paper clay slip would compact on contact with the surface, not leaving you the time to spread it evenly. If necessary, moisten the plaster surface with a wet sponge before pouring the paper clay slip.

Tip

If you wish to make a slab a few millimeters thick, place a net fabric or tulle over the plaster tile before pouring the slip. This will allow you to easily lift the slab off the plaster once it has reached the right consistency. If it dries completely on a plastered surface without being separated from it, the slab will end up curling.

Drying Steps

Excess water is initially removed from a paper clay slip from the bottom as the moisture is actually absorbed by the plaster. When the consistency of the clay increases, the water is more easily removed through the top, by evaporation. But the fibers also diffuse the water contained in the plaster through the slab, strongly slowing down the drying process. This phenomenon is stopped if you lift the slab, then put it back to introduce a film of

air between the two. You can then transfer the slab to another absorbent surface, such as a particle board, to continue drying.

Flat, Even Slabs

Whether rolled or prepared by casting paper clay slip, and whether at wet/plastic or firm, handle paper clay slabs very carefully if you want them to remain flat after drying and firing. Avoid lifting them by pulling on one side vertically, as this twists the alignment of the clay particles and fibers, causing distortion later on. Do the opposite movement to rebalance their arrangement.

To ensure flatness, roll the clay-paper slab just before you start drying. Make sure the slab does not stick to the surface below it, and roll it with some pressure. Cover it with a plastic bag to slow down the drying process and prevent it from drying too quickly around the edges.

Perfect flatness can be achieved by placing the wet slab between two absorbent boards for a few days, always checking to be sure that it does not stick to them. When firing, place high-melting-point sand on the firing plate to ensure that the shrinkage happens with minimum stress.

Molding Slabs

Slabs of clay intended for molding require the use of a support at a wet/ plastic consistency, and up to the leather hard stage. Whether a mold or simple crumpled paper padding, the shapes and materials of these supports are varied. Paper clay makes this type of shaping easier due to rapid firming. Use a hair dryer or heat gun while working. A medium to high fiber content guarantees good hydrophilicity and cohesion. With these supports, you can produce whole pieces or elements to be arranged and assembled at different stages of moisture content. Make sure that the shaping suits the type and contour of the supports.

Untitled, Wayne Fischer. Fibers bring great freedom when shaping and assembling porcelain slabs. 22 x 19 x 12 in. (57 x 49 x 30 cm).

Open Slump Molding

Plaster is the ideal material for a concave mold when you want to make an open or "oblique-angle" shape, meaning one without pronounced cavities or protrusions. Place the clay slab against the plaster and smooth it with your fingers or a damp sponge to fit the shape.

Trim excess clay with a knife. The plaster absorbs the water, and the paper clay separates from the plastered surface as it dries.

Clay adheres to absorbent materials such as wood or terra cotta, and separation can be difficult. On this type of support, apply plastic food wrap or an oily insulating agent such as liquid wax to prevent absorption and fiber attachment.

In the case of non-absorbent plastic or glazed ceramic supports, everything will depend on the consistency of the paper clay. If it is firm, it will have little interaction with the

Drying in a plaster mold.

support and will come off without any problem when drying. If the slab is still very malleable, or if it is necessary to remove it quickly, cover the support with an open weave fabric (netting, gauze, etc.) or cover it with detergent (e.g., liquid soap). When starting to shape, the clay may not have the ideal consistency. This is a reality that must be taken into account, and it is necessary to adjust the handling accordingly.

The step-by-step guide here breaks down the making of a stoneware bowl.

1 Brush the interior of a glazed earthenware dish with liquid soap.

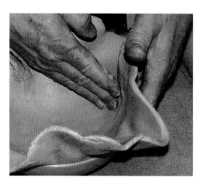

2 Place a paper clay slab on top and use your fingers to press it against the wall of the dish.

3 Cut any extra off with a knife using the edge as a guide. Finish off the bowl.

4 Firm up the paper clay with a hair dryer.

5 Unmold, sliding the two walls against each other.

Bowl in enameled stoneware by Jean-Pierre Thévenin.

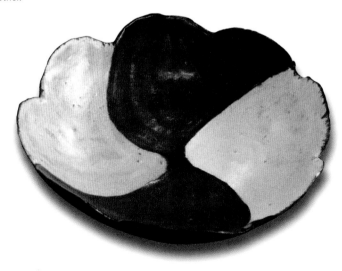

Open Hump Molding

If you are using a hump (convex) support, remove the piece from its mold as soon as it has firmed up and before it contracts; it's best at the leather hard stage. When the wall is thick, there is no risk of cracking with a medium or high fiber content, but separation of the paper clay from a rigid mold is difficult when dry.

In this case, cover the support, absorbent or not, with a plastic food wrap or stretchy fabric (old pantyhose is ideal) that you leave hanging over the edge for easy removal. You can also use synthetic foam or bubble wrap to absorb the shrinkage stress so the support can easily be removed. Supports made of crumpled paper or cardboard can be removed easily, but they require forced drying of the piece as they soften during shaping.

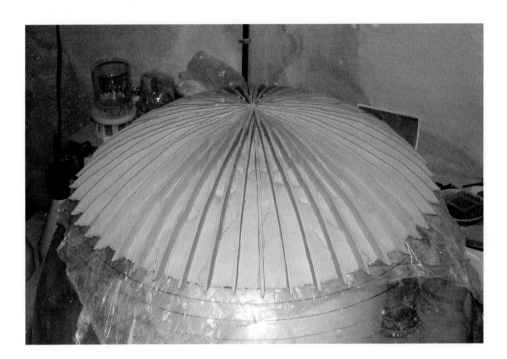

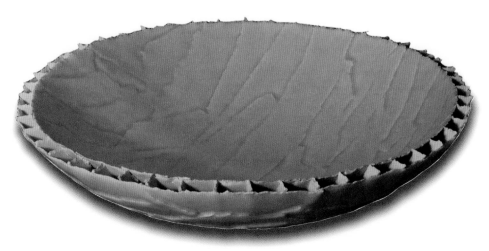

Double-walled bowl,
Xavier Duroselle.
Porcelain and celadon.
Diameter 16.5 in.
(42 cm).

Here is how to make the cap of a stylized mushroom.

1 With a knife, cut the mushroom cap out of a paper clay slab.

2 Cover a Styrofoam ball with pantyhose or tights.

3 Place the ball on a flowerpot. Place the slab on top and shape.

4 Use soft paper clay to shape the top of the cap, then refine the edges.

5 Firm up with a hair dryer, then remove from the Styrofoam ball.

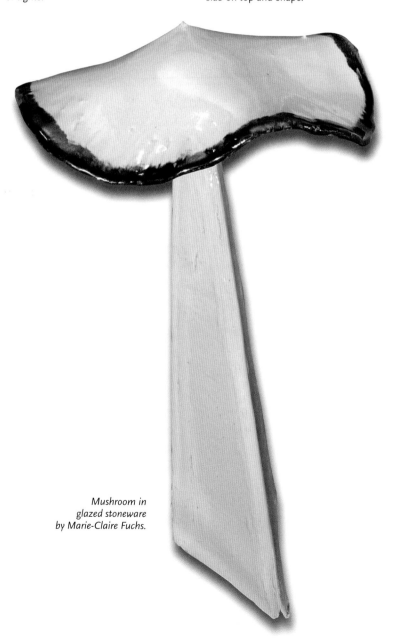

Mushroom in glazed stoneware by Marie-Claire Fuchs.

Closed Shapes around Disposable Supports

Pronounced hollow or convex shapes, folded over or closed, must be made using a material that is easy to remove when the paper clay slab has firmed up or dried. Place sand, Styrofoam beads, or sawdust in a cloth bag, pantyhose, or tights, or blow up a balloon. Place the paper clay on top and adjust the shape as you go, firming it up if necessary. Once the paper clay is firm or dry, open or pierce the support and remove the filling material.

1 Fill pantyhose or tights with sand.

2 Roll a paper clay slab around the pantyhose.

3 Make a second slab and shape it as well.

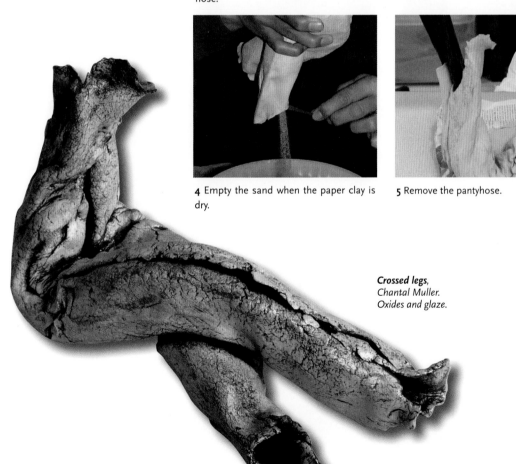

4 Empty the sand when the paper clay is dry.

5 Remove the pantyhose.

Crossed legs,
Chantal Muller.
Oxides and glaze.

Cutting and Assembling Slabs

Between Wet Stage and Leather Hard Stage

Cut the slabs with a knife and then start to assemble. When they have enough stability but are still soft, join the surfaces with finger pressure. If they are stiff, brush them with paper clay slip.

Charles Eissautier assembles his large pieces by layering strips of paper clay. The large size of the piece requires waiting for each new row to firm up before adding the next ones. The application of paper clay slip allows them to stick together firmly. Photo by N. Hubert.

***Pears**, Claire and Charles Eissautier. Height 35 in. (90cm). Finished in pigmented micro-concrete. Fired at 2012°F (1100°C). Photo by P. Henry.*

For right angle joins, offset the edges to be joined by a few millimeters and smooth the overhanging clay toward the slab to weld together. Reinforce inner corners by spreading with soft paper clay and possibly blowing hot air to firm it up.

Score beforehand the surfaces where you will be joining any weight-bearing elements (such as handles) or elements that will be exposed to extreme changes in temperature, especially during a raku firing.

The steps to making a stoneware vase are described in the following.

1 Brush paper clay slip on surfaces to be overlapped. The paper clay must be firm.

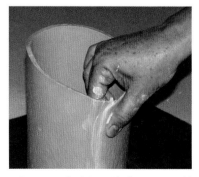

2 Compress the joint with fingers to weld the parts together.

3 Place paper clay slip on the wall and on the decorative element. Press them together.

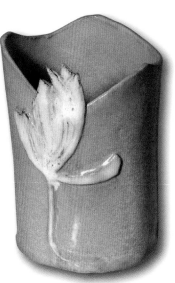

4 Place paper clay slip on the bottom edge of the cylinder and around the edge of the base, which must be a slightly larger diameter.

5 Assemble the two parts, then press and smooth clay up from the base on the cylinder to weld together.

Glazed stoneware vase by Ursula Sevin.

Assembling when Dry

Fibers give great cohesion to dry paper clay. The slabs must be cut with a sharp tool, scissors, or a saw. Straight cuts are made by scoring the surface with a sharp knife. Then bend where scored to separate the two parts. Rounded cuts on a slab a few millimeters thick can be made with scissors. A small saw is needed to cut thick slabs. Smooth the edges with a wet sponge to remove tool marks and settle any clay dust from the cut.

Cut out a pattern with scissors.

Saw to alter.

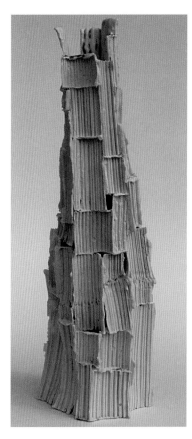

To assemble the dry slabs, they must be moistened about 0.4 in. (1 cm) along the edges. Dip them in water for about thirty seconds. If you can't do this due to their size, apply water repeatedly with a brush or sponge. Then cover both surfaces to be joined with paper clay slip.

Quick, accurate work, without going back over it, ensures the best adhesion. Place the surfaces to be joined against each other when the paper clay slip is still liquid and shiny. Hold in place until it dulls. Then smooth with a finger and reinforce the joins with soft paper clay.

***Phrygane**, Thérèse Lebrun, porcelain, fired in reduction at 2336°F (1280°C). Height 16 in. (41 cm). Dried, stamped slabs assembled using paper clay slip on combustible materials. Photo by P. Gruszow.*

1 Score the surface of the porcelain paper with a sharp tool against a lath.

2 Place the cut line on the edge of the table and gently bend down to separate the two parts.

3 With a brush, repeatedly apply water to the surfaces intended to be in contact when joined.

4 Coat the edges with paper clay slip.

5 Place the two slabs together on the still soft slip.

6 Wait a moment for the slip to compact, then gently smooth the joint. Continue joining the other sides one at a time.

Porcelain vase,
edges highlighted with gold.

Draping

1 Cut the jacket out of a thin slab of paper clay.

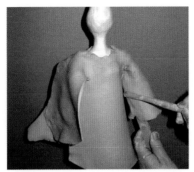

2 Place the jacket on the figure using paper clay slip.

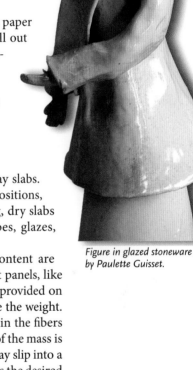

To increase the solidity of a very thin slab and make it easier to handle, use a paper clay that is a bit stiff, with a medium content of long fibers, preferably. Roll out a slab to 0.04 or 0.08 in. (1 or 2 mm) thick. Work the paper clay on a non-absorbent surface so that it does not dry out too quickly, and shape it just before it reaches the leather hard stage. Spray with water if cracks appear. Drape it and make fabric folds, clothing your figures like a seamstress cutting out clothing from a pattern. In this case, the fabric is a thin slab of clay.

Figure in glazed stoneware by Paulette Guisset.

Suspensions

The cohesion provided by the fibers makes it easier to work with paper clay slabs. You can create wall art, add sculptural elements to its surface, create compositions, attach pieces, or even embed various materials (see p. 91). As for finishing, dry slabs accept various paints or patinas. If you are going to fire it, apply engobes, glazes, oxides, etc.

Paper clays with a high fiber content are advantageous for creating wall art panels, like the one in the step-by-step guide provided on the following page, as they reduce the weight. When drying, the water retained in the fibers is replaced by air and the density of the mass is greatly reduced. Pour the paper clay slip into a wooden frame and use it as soon as the desired consistency is reached. Such panels can do without firing and receive pigments.

The Misfortunes of War—Baghdad,
bas-relief by Elisabeth le Rétif.
8 x 12 in. (20 x 30 cm). Very thin,
raised paper clay, vitreous engobes
and cold smoke fired.

1 Prepare a 10 percent porcelain paper clay–based slip.

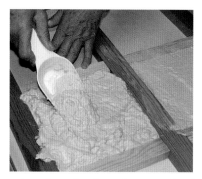

2 Spread out the slip in frames made of laths laid on a plaster tile.

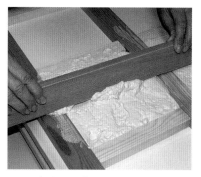

3 Level the surface with a lath. Allow square tiles to firm up for a few hours before moving them.

4 When at the leather hard stage, mark the surface of the tiles with various tools (agate, ribbon tool, wood modeling tool, etc.).

5 Apply India ink with a brush and let dry before applying the gold leaf. Glue the tiles onto plywood with epoxy glue.

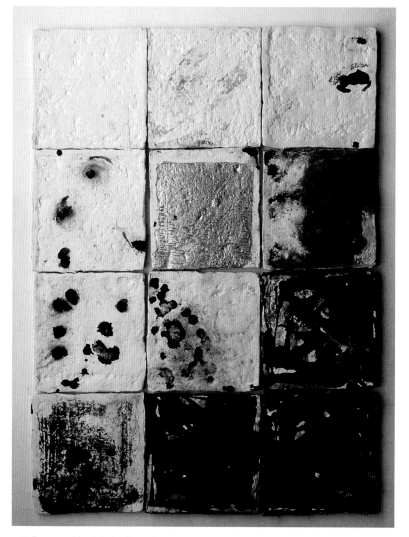

Wall art panel by Caterine Beaugé.
22 x 28.75 in. (56 x 73 cm).
India ink and gold leaf. Not fired.

Throwing

Appearance of a piece thrown with short-fiber commercial paper clay.

Appearance of a piece thrown with a medium-fiber-content porcelain paper clay made with everyday paper (mixture of long and short fibers).

Paper clay with 1 percent or 2 percent fiber content is suitable for shaping a ball on a pottery wheel. At higher levels, the walls will be difficult to refine. However, the length of the fibers is of great importance. The longer they are, the more difficult the throwing is. A paper clay with a medium rate of short fibers retains characteristics close to a traditional clay. While the hydrophilicity of paper clay is an advantage when centering, trimming, or assembling, it becomes a disadvantage if one wants to assemble and refine the pieces during the throwing process. Paper clay is not suitable for learning wheel throwing.

Traditional Throwing

While for other techniques kneading is not of primary importance, it remains so for paper clay throwing. Your work could be put on hold if the material is not homogeneous or if it contains air bubbles. Use a paper clay with a wet, plastic consistency. Throw with as little water as possible or coat your hands with slip.

Paper clay offers little resistance to centering and opening. Pulling up and shaping a wall, on the other hand, requires precision and dexterity: these steps must be done quickly, because the water brought by the hands diffuses immediately through the wall, which softens and bends.

If you are used to throwing using a rib, close the angle of contact with the wall to avoid tearing the fibers.

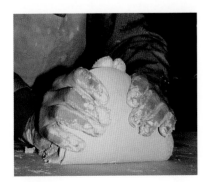

1 Knead the paper clay.

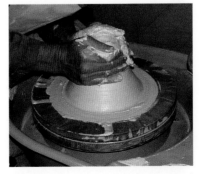

2 Place a ball on a bat attached to the wheel and surround it with wet hands to center it.

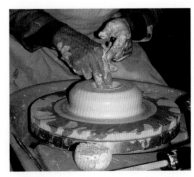

3 Push down to open up the centered paper clay.

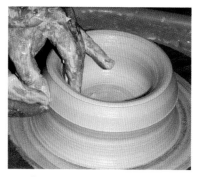

4 Pull up the wall, pressing from both sides.

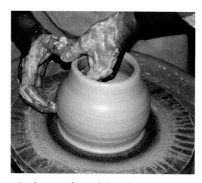

5 Push out with inside hand to curve it outward.

Trimming

To modify or refine the lines, you can trim a thrown piece when it is at the leather hard stage, as for a traditional clay work. If you have inadvertently left the piece to harden, dampen the surface to be reworked with a water-soaked sponge. The paper clay will soak up the water and quickly soften on the surface. Trim the piece with a ribbon trimming tool.

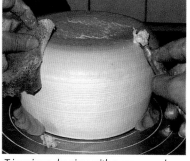

Trimming a dry piece with a sponge and a ribbon tool.

Throwing Large Pieces

A thrower is limited by the strength required to center large quantities of clay. Paper clay, more reactive at this stage, requires less effort and therefore makes it possible to throw a larger volume. To reduce the amount of water, wet your hands as little as possible and sponge the surface and interior of the piece regularly. If the walls soften, wash and dry your hands,

Firm up the walls with a hair dryer, then continue throwing.

then quickly take action with a hair dryer or heat gun.

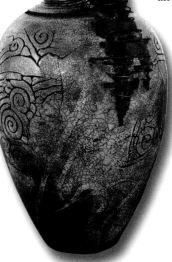

Earthenware jar by Pierre Ohniguian. Height 53 in. (135 cm), diameter 36 in. (92 cm). Piece partly stamped, thrown, and combined with metal. The use of paper clay reduces the weight of this jar. Raku firing and smoke firing.

Modifying Thrown Pieces

The cohesion and the resistance to shrinkage provided by the fibers make it possible to modify the shape of a wall. You can work on a piece that has just been thrown as well as on a piece that has already firmed up. If the walls are dry, spray with water before working on them.

1 Distort the wall of a pot after it has been thrown.

2 Scratch the surface using a metal scraper.

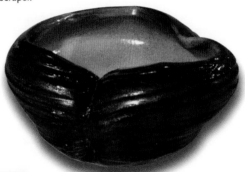

Throw several pieces at a time and wait until they are firm, then cut them into several parts. You can then assemble them no matter how wet they are (e.g., to put dividing walls inside a pot).

Pot by Marcel Ball. Porcelain paper clay with 1 percent paper, thrown and glazed.

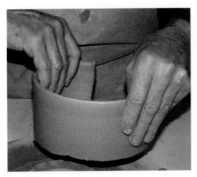

1 Salvage the wall of a thrown piece with a wire clay cutter.

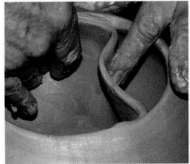

2 Add the wall to a thrown piece that has become stiff using paper clay slip created during throwing.

To add on some hand-built parts (like handles), it is not necessary that both parts to be joined be exactly at the same stage of wetness (see p. 96). Generally speaking, we can say that fibers reduce most technical constraints of any work on a piece after throwing.

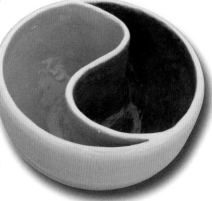

Glazed pot with interior wall by Marcel Ball.

Choose papers that form a smooth paper clay slip at low concentration, such as newspaper.

Casting

By pouring clay slip into a plaster mold (which absorbs water), identical simple or complex pieces can be quickly reproduced. As soon as the wall is formed by contact with the plaster, pour out the excess slip and save it to use for another casting. Ceramic suppliers offer ready-to-use casting slips and plaster molds. By adding fibers, you will increase the resistance of the pieces to handling, which will allow you to make changes to the final shape. The surface in contact with the plaster will remain smooth while the surface in contact with the air will have an irregular appearance. Do not add more than 2 percent of paper to the slip. More than that will make the walls of the casting uneven and lumpy.

Paper Clay Casting Slip

Ready-to-use casting slips contain a deflocculant that makes the clay more fluid (see p. 16). However, it is often necessary to add water to the slip to make it coat the mold evenly. The setting time is ten to fifteen minutes for a wall thickness of about 0.16 in. (4 mm).

If you are preparing a casting slip from powdered minerals, add a deflocculant to reduce the volume of water required. Do not exceed the amounts indicated by the manufacturer, as the deflocculant will set the slip at rest and will not drain properly from the mold.

The step-by-step guide given here shows making a 2 percent paper slip.

Supplies:
For the slip
2 liters of ready-to-use commercial casting slip
or
2.5 kg of porcelain powder
1 liter of water
6 g of Dolaflux
For the paper pulp
50 g of newspaper
5 liters of water

1 Prepare the casting slip and sieve it.
2 Prepare the paper pulp and drain it to obtain about 2 cups (0.5 liters) of pulp.
3 Mix the two preparations to obtain the paper clay casting slip.
4 Let it rest to eliminate the air introduced into the body during preparation.

Casting the Paper Clay Slip

Mix the paper clay slip carefully to make it fluid and homogeneous. Then pour the paper clay slip into the mold, as you would for a traditional clay casting. The presence of fibers increases the waiting time before opening the mold. Indeed, the casting is done with more water and the fibers slow down the shrinkage of the piece. Avoid consecutive pours; let the mold dry between uses.

1 Carefully remove dust from the mold and the seam area with a brush or sponge.

2 Close the mold and hold it in place with a rubber band.

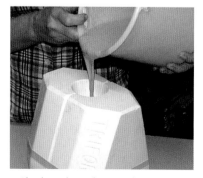

3 Slowly and evenly pour the paper clay slip right in the center of the mold's pouring funnel (which sits on top of the vase form). Fill until flush with the top.

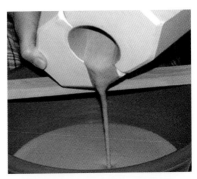

4 Wait about ten minutes until the paper clay slip has sunk to the level of the vase. Empty the mold.

5 Leave the mold in an inclined position for five minutes.

6 Clean the opening when the clay has dulled. Remove the paper clay from the pouring funnel with a strip of cut plastic card, taking care not to damage the mold.

7 Wait about one hour. The wall of the vase should separate from the plaster. Allow air to enter this space before opening the mold.

8 Separate the two parts of the mold by holding the base with two fingers. Remove the upper part by lifting it vertically, without forcing it open; if there is resistance, wait until the next day.

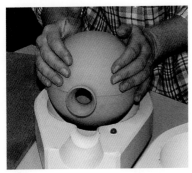

9 Wait a moment before unmolding the vase completely to avoid distorting it.

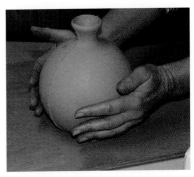

10 Place the vase on an absorbent surface.

11 When the vase has reached the leather hard stage or is dry, scrape off any traces of the join with a small knife.

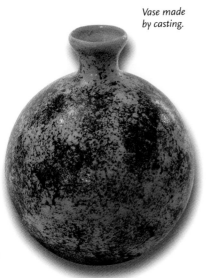

Vase made by casting.

Modifications

Many variations are possible from the same mold. Cast paper clay is resistant to pressure and cutting. It can be worked on after unmolding, when it is

leather hard, or after drying. Assembling and adding on are possible at various degrees of wetness using paper clay casting slip.

Here are some possible variations using a mold with black engobe under transparent glaze.

Draped Vase

1 Press with your hands on the walls of the vase shortly after unmolding to distort the shape vertically.

2 Form depressions one by one with simple finger pressure.

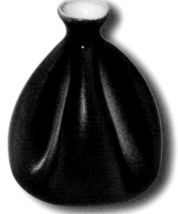

3 The result is a draped vase.

Oval Pot

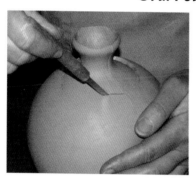

1 With a small knife, cut off the neck of the vase that has stiffened a bit.

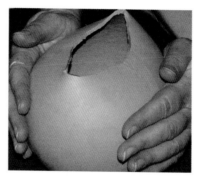

2 Place your hands around the middle to gradually change the shape to an oval.

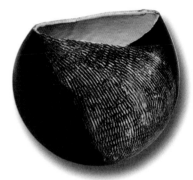

3 The result is an oval pot.

Cubic Pot

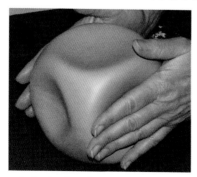

1 Strike the firmed vase against the work surface to form the base and the four sides.

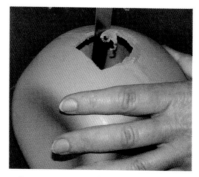

2 Cut an opening with a serrated knife and gradually enlarge it.

3 The result is a cubic pot.

Jagged-Edge Pot

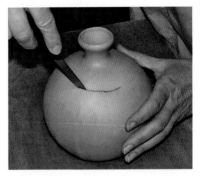

1 Cut off the upper third of the firmed vase with a serrated knife.

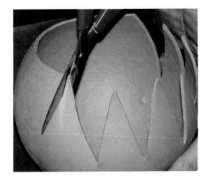

2 Cut into the wall with scissors.

3 The result is an open-necked, jagged-edge pot.

Armatures

An armature acts as a support and facilitates the assembly of spindly, willowy, or bulky pieces, while at the same time being an integral part of the piece. To resist drying shrinkage, armatures can be used with medium- to high-fiber-content paper clays.

The pieces have very good drying strength. If you wish to fire, you will need to consider the deterioration of armatures and provide a clay covering strong enough for the pieces to be stable. If there is metal, stay below the maturing temperature of the clay; otherwise, the firing shrinkage could cause cracking.

Wire Armature

Choose a piece of 0.059 in. (1.5 mm) wire. It is easy to twist and shape, and allows you to create long, thin curves, like those of a butterfly, for example. Directions for making the butterfly are provided in the following. After twisting, braiding, or putting together the wire structure, it must be covered with paper clay. If the fiber content is medium, cover it in portions, let it dry, and then fill in the gaps. If the fiber content is high, cover the wire completely. The firing temperature should not exceed 1832°F (1000°C); otherwise, the molten metal may penetrate the wall and make black spots or blisters on the surface.

Kanthal wire, which is similar to the kiln's heating elements, is more expensive than conventional wire but withstands the firing well. It can be found at ceramic suppliers.

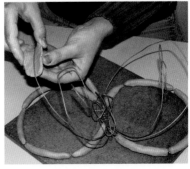

1 Cover the wire frame with paper clay in sections of about 2 in. (5 cm). Allow to air dry.

2 Use a brush to moisten the ends of the sections to be joined.

3 Apply paper clay slip.

4 Add paper clay to make joins.

5 Use a finger to smooth out and even the surface.

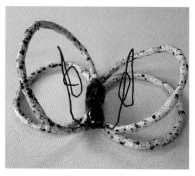

Glazed butterfly by Rachel Meiss. Fired at 1000°C.

Steel Armature

Pushmi-Pullyu, Otakar Sliva. Height 14.5 in. (37 cm). Sculpture in highly grogged paper clay mounted on a base with steel rods. Raku firing at 2012°F (1100°C).

Steel is more difficult to shape than wire. Steel rods can be used for tall, thin figures or will work as both a base and an armature.

All kinds of stainless steel objects can be combined with paper clay. Choose a clay with high fiber content to ensure good resistance to drying shrinkage and to avoid cracking. However, a low-fiber clay may be suitable if it contains a high grog or sand content to reduce its shrinkage rate. Steel can withstand temperatures up to 1832 to 2192°F (1000 to 1200°C), depending on its composition.

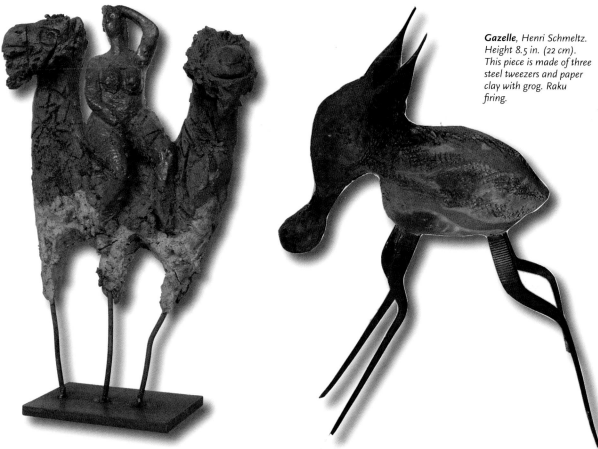

Gazelle, Henri Schmeltz. Height 8.5 in. (22 cm). This piece is made of three steel tweezers and paper clay with grog. Raku firing.

Wire Mesh Armature

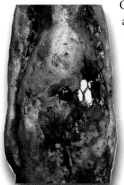

Galvanized wire mesh fencing with small hexagonal gaps, known as chicken wire, can be used to create large volumes to be covered with paper clay. For smaller areas, use florist wire, which is easier to shape. The fibers of the paper clay cling to the mesh of the chicken wire, holding the clay in place. Longer fibers provide a better hold. If you are firing, be sure to make a clay wall that is thick enough, as the mesh becomes very brittle above 1832°F (1000°C)—making it crumbly after cooling.

Open Shapes

When access is possible from both sides of the mesh, it is easy to apply a wet/plastic clay. If you want to leave small openings in the wall, use a very soft paper clay, which clings to the mesh when smoothed on by hand. Finish by applying sawdust to your hands to reduce and even out the thickness of the clay. The sawdust prevents the soft clay from sticking to your fingers; it then burns off when fired and disappears.

The example shown here is a lamp.

1 Form a cylinder with chicken wire and twist the cut wires to close it.

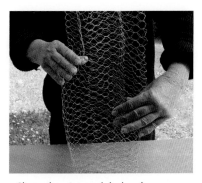

2 Shape the wire mesh by hand pressure.

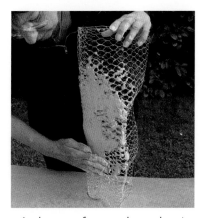

3 Apply very soft paper clay to the wire mesh.

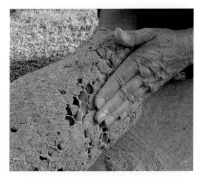

4 Smooth out the thickness of the paper clay with both hands coated with sawdust. Leave openings.

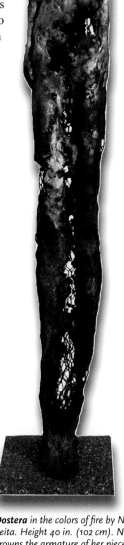

Dostera *in the colors of fire by Nina Seita. Height 40 in. (102 cm). Nina Seita drowns the armature of her pieces in the paper clay. Raku firing and smoke firing.*

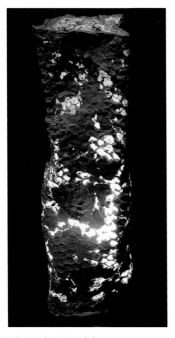

Clay and wire mesh lamp by Caterine Beaugé. Fired at 1832°F (1000°C).

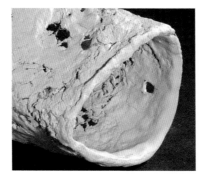

5 Once the paper clay has stiffened, open up the hexagonal mesh and reinforce all around it with paper clay so a cable can pass through and a bracket and socket can be attached after firing.

Total Coverage and Narrow Shapes

To cover a wire mesh without access to the interior volume, apply thick paper clay slip to glossy paper and place the brushed side against the mesh. Cover the entire surface like this (bond coat). Then apply the next layers of thick paper clay slip on the paper, until a shell a few millimeters (about ⅛ in.) thick is formed.

This technique allows you to make large pieces, larger than your kiln. Light and easy to move, they will remain unfired. You can paint them, burnish them, or possibly varnish them as protection against moisture.

To avoid applying a bond coat, cover the mesh with gauze. The weave will let a little material through.

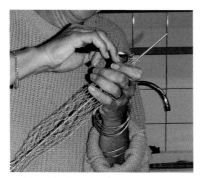

1 Shape a body with galvanized wire mesh around a threaded rod anchored to a base. Use pliers to bend the ends of the cut wire toward the interior.

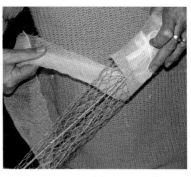

2 Wrap gauze around the wire mesh, overlapping the edges.

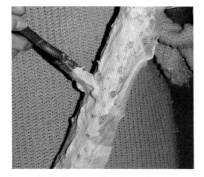

3 Apply thick paper clay slip to the gauze.

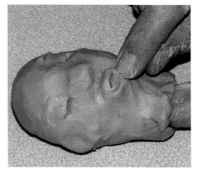

4 Make a head, then attach it to the body with soft paper clay.

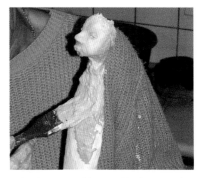

5 Apply a second layer of thick paper clay slip when the first layer has dried, then a third one.

Wood or Rattan Armature

Plant materials—wood or rattan chopsticks or skewers, etc.—can also be used as armatures. Softened by soaking in water for twenty-four hours, rattan is easily shaped and held in place with string. Cover it with paper clay in the same way as with a wire frame (see p. 85). Plant materials have the advantage of not interacting at all with clay during firing. Contrary to metal, they are burned up and leave only ashes.

Armature made of rattan.

Miscellaneous Techniques

Other original or unexpected processes are made possible by the presence of fibers in the clay. Here are several tested ideas that can guide you in your future research, along with the information given in the preceding pages.

Dancer built on a rattan armature, by Clémence Lang. Patina applied after firing.

Inclusions

While traditional clay can only handle small components such as sawdust or grog, paper clay with a medium to high fiber content can receive a much wider variety of materials. They are introduced into the clay by kneading.

Plant materials (rice, wood shavings, etc.) or minerals such as glass stay in place without causing cracks when drying. Due to the pottery's porosity, cohesion is not affected by firing. Nonetheless, check the behavior of the inclusions themselves. Grains of rice and kernels of corn, for example, will expand upon firing and will burst on the clay's surface. The kiln and the room must be well ventilated, as when they are burned up, plant materials release smoke that will be added to that from the paper. The step-by-step guide below shows the inclusion of glass in clay.

Jar by Pierre Ohniguian. Height 49 in. (125 cm). Hand-built with a turned neck and inclusions of metal rods, mix of paper and high- and low-temperature clays, engobes, raku firing, and smoke firing.

Figure on wire mesh with acrylic paint by Fabienne Glauser. Unfired.

1 Knead pieces of safety glass into a paper clay with 3 percent fiber.

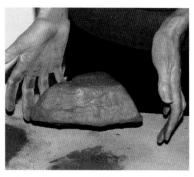

2 Shape it, letting it fall on an absorbent surface.

3 Noticing a crease on the surface of the paper clay.

4 Taking away clay in this area.

*Lamp by Barbara Wagner.
Porcelain paper clay with quinoa inclusions.
Fired in electric kiln at 2246°F (1230°C).*

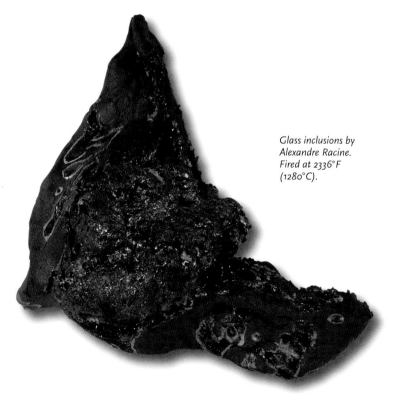

Glass inclusions by Alexandre Racine. Fired at 2336°F (1280°C).

Boustrophédon, Aline Faucher, made during a workshop led by Elisabeth le Rétif at the Regional Museum of Pottery in Ger (Basse-Normandie). Clay shards embedded in a raw piece of grogged clay with high fiber content.

Embedding

A number of materials can be embedded in paper clay for a particular creation, such as broken ceramic pieces, glass, plants, etc. Press them into the surface of the clay or deeper. Thin items, such as plant stems, are pushed directly into the paper clay. With a medium to high fiber content, there is enough drying shrinkage to hold everything in place without causing cracks.

Adjust the firing temperature to the embedded items, which may change appearance at the high temperatures of a ceramic kiln. When embedding plants, simply let your creations dry as they would burn up if fired.

The following step-by-step guide shows the embedding of various materials in clay.

Vase, Lilli Ball. Height 17 in. (44 cm). Embedding of porcelain shards in paper clay. Raku firing.

1 Pinch the edges of a paper clay slab.

2 Embed flat items such as a bottle cap by pressing with a finger.

3 Push in the stem of a beech nut husk. Do the same for other plants to be poked in, then let dry.

Composition by Sylvie Hug. Various items selected from nature, embedded in raw paper clay that is simply dried.

Combining Clays

The presence of fibers reduces drying stresses, allowing clays of different origins to be combined. Use clays of various colors for your paper clay, or place paper clay elements on a traditional clay piece. However, if they don't mature at the same temperature, cracks or deformations may appear during firing.

A grogged black stoneware attachment joined to white stoneware paper clay.

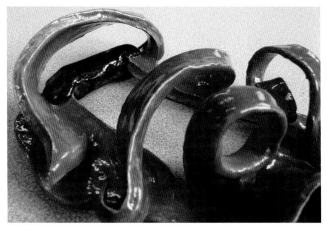

***Curls**, Alexandre Racine. Combined clays after glazing and firing at 2336°F (1280°C).*

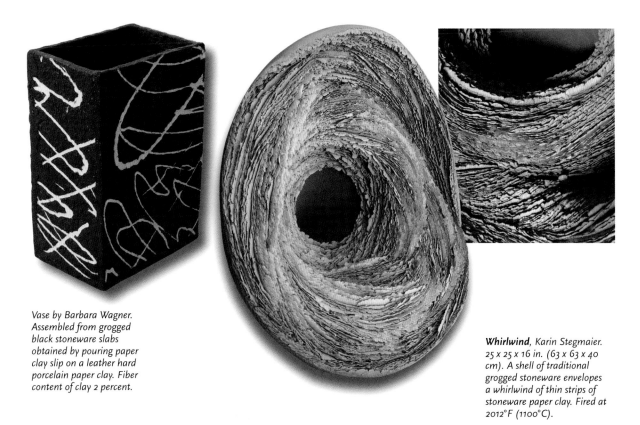

Vase by Barbara Wagner. Assembled from grogged black stoneware slabs obtained by pouring paper clay slip on a leather hard porcelain paper clay. Fiber content of clay 2 percent.

***Whirlwind**, Karin Stegmaier. 25 x 25 x 16 in. (63 x 63 x 40 cm). A shell of traditional grogged stoneware envelopes a whirlwind of thin strips of stoneware paper clay. Fired at 2012°F (1100°C).*

Dipping

This technique is possible with absorbent materials that will hold onto the clay and the fibers. In a large container, prepare a thick, medium-fiber-content paper clay slip. Quickly dunk a combustible item into it, possibly fabric, string, or branches as shown in the step-by-step guide that follows. Let the clay stiffen and then do it again several times. Resistance to drying shrinkage absorbs stresses, and the wall formed does not crack. After firing, these combustible materials will leave a hollow interior. If the clay wall is not thick enough, the resulting piece will remain fragile.

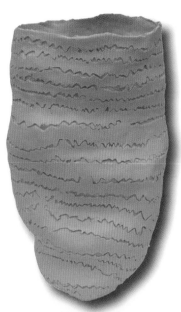

Calcification, Thérèse Lebrun.
Height 13.5 in. (34 cm). Delicate shell in porcelain created by dipping supple materials in paper clay slip. Photo by P. Gruszow.

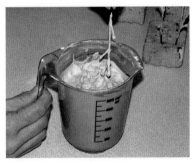

1 Dip branches one at a time in a thick paper clay slip and let this bond coat dry.

4 Cover the entire upper part of the trunk, ending around the outside edge.

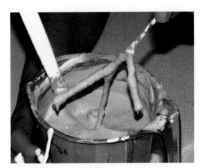

2 Repeat the dipping several times after firming up in between until the clay wall is about 0.08 in. (2 mm) thick.

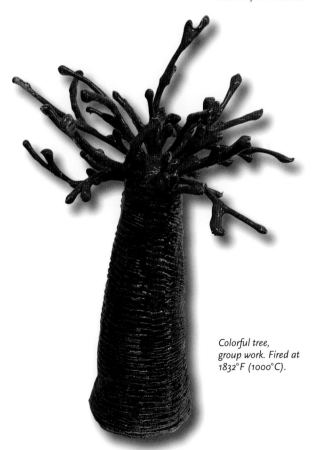

Colorful tree, group work. Fired at 1832°F (1000°C).

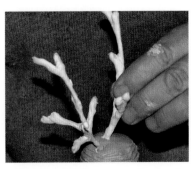

3 Create a trunk from paper clay that the branches can be poked into.

Brushing

This process allows you to easily reproduce a convex shape in a plaster mold. Avoid paper clays with a high fiber content, which are difficult to spread in this way.

Brush a thick paper clay slip or a very soft paper clay onto the mold. The water is quickly absorbed; as soon as the surface of the paper clay has dulled, it is ready for another coat. Several layers are necessary to obtain a wall a few millimeters (about 1/8 in.) thick. The paper clay separates naturally from the plaster support due to drying shrinkage. The steps to making a small dish are shown next.

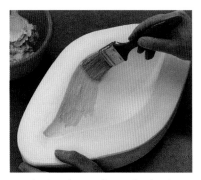

1 With a brush, coat the inside of a plaster mold with very soft porcelain paper clay.

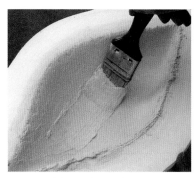

2 Wait until the surface dulls. Apply several layers in the same way.

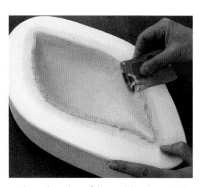

3 Clean the edge of the mold with a plastic card.

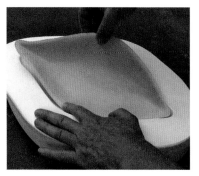

4 Unmold the dish after it has contracted and detached from the mold.

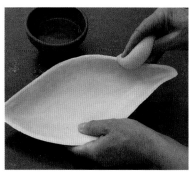

5 Smooth the edge of the dish with a wet sponge.

__Small bowl__, Liliane Tardio-Brise. Made by simply brushing on porcelain paper clay with 2 percent fibers. Terra sigillata applied, fired at 2012°F (1100°C) plus naked raku.

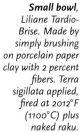

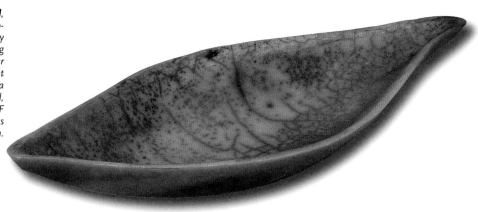

Covering a Form

This technique is similar to taking an impression. A medium- to high-fiber-content paper clay can be used to cover an existing form. Brush the form with an appropriate separating agent to facilitate unmolding. Apply wet/plastic paper clay, in slabs, strips, or small pieces. Smooth the surface and finalize the shaping. Wait until the paper clay is leather hard before cutting to release it from the form. Close the paper clay piece back up with paper clay slip.

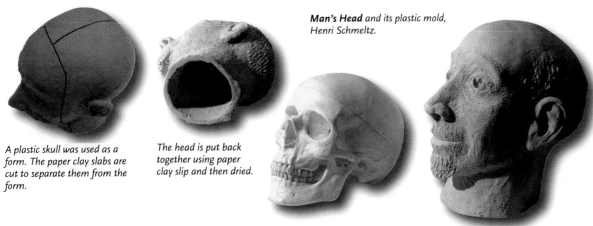

Man's Head and its plastic mold, Henri Schmeltz.

A plastic skull was used as a form. The paper clay slabs are cut to separate them from the form.

The head is put back together using paper clay slip and then dried.

Paper Clay Mold

The ease of handling pieces, their light weight, and the dry strength of paper clay make it an advantageous material for creating large molds. You can use a mold, raw or fired, to make prints from paper clay or other materials, such as fiber-reinforced concrete. Apply an insulating agent or plastic film to facilitate removal from the mold.

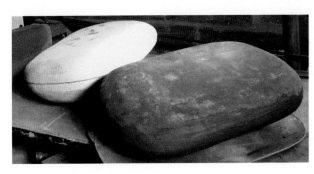

The brown paper clay stone was stamped using a two-part fiber-reinforced concrete shell. It was then used as a mold to make a new fiber-reinforced concrete stone.

A high-fiber-content grogged paper clay makes it possible to create molds that can be used to cast unique bronze pieces using the lost-wax process. The wax model is covered with paper clay (which replaces the mixture of clay and donkey dung used in the primitive ancestral method). Its resistance to shrinkage allows the paper clay to dry without cracks. After the wax is drained out, the mold is fired. It can be used for metal casting due to its porosity and resistance to thermal shock.

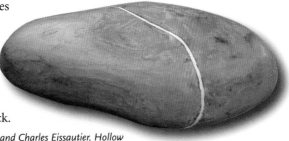

Stone, Claire and Charles Eissautier. Hollow stone in fiber-reinforced concrete.

A Paper Clay House

Both cob and paper clay contain plant fibers that form a kind of skeleton. In the case of cob, these are dry plant fragments several centimeters (a few inches) long. In the case of paper clay, the fibers are a few millimeters (less than ¼ in.) long and come from the defibrated plants of a paper pulp. The common basic element is cellulose. With the addition of water, the clay and the fibers, where all the fibers are still connected, bind together because of their affinity for water. The dry mass is then strong and compact. It is used as a filling or coating material for housing. Paper clay clings to cob with a wet surface as well as to porous materials.

The interior decor of Barbara Wagner's traditional Alsatian wood-frame house in Wolschwiller (Alsace) was made of paper clay (wall covering, partition, mobile).

Assembly

Assembling with traditional clays requires that parts being joined have an identical degree of moisture to avoid cracks during drying or firing. The presence of paper clay fibers cancels these constraints. The cohesion, hydrophilicity, and resistance to drying shrinkage make it possible to join dry or wet items or a combination of the two, and this is with 2 percent added fiber. Cracks may still appear due to drying stress if the moisture content of the assembled parts is very different, but they can be easily repaired (see p. 100).

Wet on Wet

Wet paper clays good for hand-building adhere to each other when placed one on top of the other. If they are slightly firmer, as in the case of leather hard slabs, an application of paper clay slip ensures a perfect bond.

***Didie**, Élisabeth le Rétif. Height 27.5 in. (70 cm). Figure built around a void by a succession of strips cut from paper clay slabs. Strips added must dry before continuing to work on it. Raku fired with targeted smoking.*

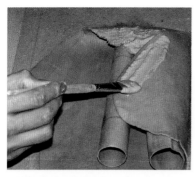

1 Using a brush, apply paper clay slip to the first contact surface.

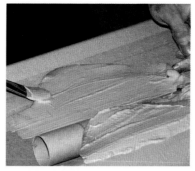

2 Coat the second contact surface.

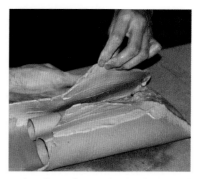

3 Place the surfaces to be joined on top of each other and press them together.

Wet on Dry

To achieve adhesion between a dry paper clay and a wet paper clay, moisten the dry part, score it, and apply a thick layer of paper clay slip. The fibers, drawn by the flow of water toward the water-hungry dry area, will connect with the wet paper clay applied.

1 With a sponge, moisten the area on the dry part where the join will be made.

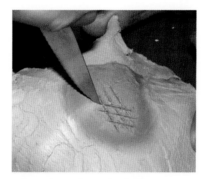

2 Score the surface with a knife.

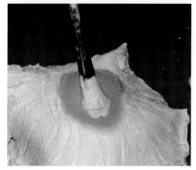

3 Coat surfaces to be joined with paper clay slip.

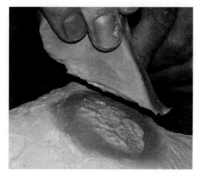

4 Put it in place, then press and smooth the join.

Dry on Dry

Claire and Charles Eissautier compose "architectures" from paper clay slabs that they cut up and let dry before modifying and assembling.

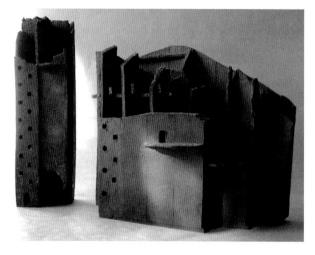

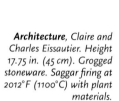

Architecture, Claire and Charles Eissautier. Height 17.75 in. (45 cm). Grogged stoneware. Saggar firing at 2012°F (1100°C) with plant materials.

When paper clay is dry, it is essential to moisten the areas to be joined, then brush them with paper clay slip. For slabs modified beforehand, go ahead and join by simple contact. Hold the joined pieces until the paper clay slip has set (see p. 75).

If the assembly requires some extra care with placement, if the part being connected is weight-bearing, or if the part is subject to thermal shock during firing, deeply score the softened surfaces and apply paper clay slip to ensure complete adhesion. Soften any surface cracks that appear during the drying process and smooth them out with paper clay slip.

1 Moisten surfaces to be joined with a wet brush.

2 Use a knife to score the softened contact areas.

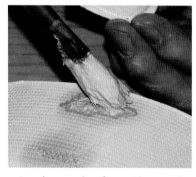

3 Coat the scored surfaces with paper clay slip.

4 Put the part in place immediately and apply a moderate amount of pressure.

5 Fill in the angle of the join with soft paper clay and smooth with a finger to finish.

Modifications

Clay is shaped both by removing and adding material. However, when clay is dry and does not contain fibers, adding water (to adjust the shape or make an addition) leads to the formation of cracks. When cellulose fibers are present, water circulates easily and the cohesion of the mass is improved.

Using Pressure

A paper clay piece is easily modified by finger pressure until it reaches the leather hard stage. Beyond that or when the piece is dry, an addition of paper clay slip or water is necessary to bring the paper clay to the wet stage. Always proceed in stages, without excess water.

On thin walls, changes that can be made by applying pressure are limited when they result in widening a wall by reducing its thickness. A modification can also only be made on the rewetted part of a piece. The steps presented here show how to rework a vase deformed during drying.

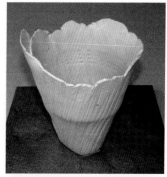

This vase was deformed during drying by the support used for shaping.

1 Spray the deformed area with water.

2 Wrap the area to be reworked with a cloth soaked in water.

3 Tap with a spatula until the deformation is gone, then let dry.

Removing Material

To remove soft clay, use your fingers or a ribbon tool. A knife is useful if the clay is firm; at the leather hard stage, choose a serrated one. When a paper clay piece is dry, use scissors and scraping tools to fix thin walls. Thick, strong walls require a small saw.

Removal tools.

Adding Material

A paper clay slip will adhere to any surface that draws in water, which pulls in the clay-covered fibers. But for anchoring to occur and remain after drying, the absorbent surface must catch the fibers or let them penetrate. When modifying a piece by adding clay, the use of paper clay slip guarantees good adhesion on clay that is still wet. The addition of water is essential on dry parts or porous pottery. Additions of soft paper clay are used to fill in cavities and smooth out clay surfaces, whether or not they contain fibers.

Conditions for anchoring a fibered mixture on a clay (whether or not it contains fibers)

Fibered Mixture \ Clay (with or without fiber)	Wet/Plastic Stage	Leather Hard Stage	Dry	Fired (very porous)	Fired (non-porous)
Paper clay slip	yes	yes	+ water	+ water	no
Soft paper clay	yes	yes	+ water + paper clay slip	+ water + paper clay slip	no
Wet paper clay	yes	+ paper clay slip	+ water + paper clay slip	no	no
Leather hard paper clay	+ paper clay slip	+ paper clay slip	+ water + paper clay slip	no	no

Repairs

Because of the great freedom that paper clay provides when building, the different wall thicknesses, and different levels of humidity, cracks can appear during the drying process. These cracks are common and easy to patch. It is best to allow paper clay pieces to air dry to reveal the stresses, allowing these areas to be dealt with before firing.

Broken pieces are characteristic of traditional dry clay, and the addition of fiber is a great help. Be sure to use the same clay for repairs; otherwise you will get a difference in color or problems with firing if the maturing temperatures of the clays are different. A medium fiber content is ideal.

Filling Cracks

Small Cracks

When clay-covered fibers are visible in a crack, wet and smooth the surface with a finger coated with paper clay slip.

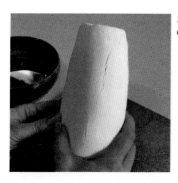

Small crack on dry paper clay.

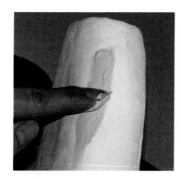

Follow these steps: moisten the cracked area with a wet finger and apply paper clay slip to the crack.

Open Cracks on a Dry Clay Wall (with or without fiber)

Start by wetting the perimeter of the crack, then apply paper clay slip. If the cracks are wide open, use soft paper clay. After drying, it may be necessary to refill smaller cracks that appear during drying.

Crack on a traditional clay piece that appeared during drying.

1 Apply water to the crack with a brush until a slip forms on the surface.

2 Fill the crack with soft paper clay.

Open Cracks on Porous Pottery

Proceed in the same way on fired pottery that is still porous as on a dry clay wall. Allow time for the water to soak in before applying the paper clay slip. Another firing is necessary to consolidate the piece.

Repairing Broken Pieces

On Dry Clay

Dry paper clay pieces are rarely broken. They are repaired as when joining dry-on-dry (see p. 98). On the other hand, non-fibrous dry clay pieces are frequently broken during handling before firing. Applying water to the surfaces to be joined, scoring, and applying paper clay slip will restore a very good adhesion to the broken parts. The repair of a traditional clay is shown in this step-by-step guide.

1 Apply water with a brush to moisten the broken edges.

2 Score the edges with a fork.

3 Apply paper clay slip to the edges.

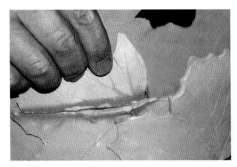

4 Fit parts together, then smooth the join with paper clay slip.

This mask made from grogged stoneware was damaged during a primitive firing.

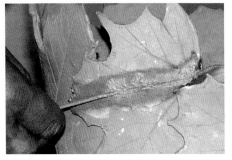

5 Add design again with a toothpick.

6 Spread paper clay slip on the other side to reinforce the join.

On Bisqueware

As long as a ceramic material is very porous, it can receive a mixture of clay and fibers. Prepare a paper clay slip (see p. 104) and a soft paper clay with 3 percent fiber with the clay used to make the piece to be repaired.

First wet the damaged piece before applying the clay and fiber mixtures. Additions are then possible, but avoid weight-bearing elements, such as handles. When cracks appear from drying, wet them and brush with paper clay slip. Bisque fire the piece to ensure good adhesion of the additions if you want to glaze the piece.

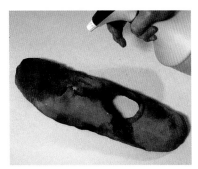

1 Spray water on the surface of the damaged mask.

2 Use a brush to spread paper clay slip over the areas to be repaired.

3 Fill in the cavities with soft paper clay. Spray with water, smooth the surface with your hands, then leave the mask to air dry overnight.

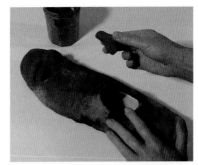

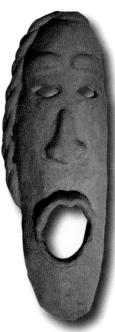

4 Add paper clay slip to the cracks formed by drying shrinkage of the material added. Smooth with fingers.

5 Mold the eyebrows, nose, and braid with paper clay. Coat the areas that will be placed on the mask with paper clay slip. Press to weld them together.

The repaired mask is fired at 2336°F (1280°C) in an electric kiln.

Continuing Work on Dry Traditional Clay

The shaped and dried paper clay is rehydrated by spraying. The water is absorbed quickly, and the cohesion of the wall is not affected as long as the volume of added water does not go beyond the wet stage. A clay with no fiber will crack easily due to the stresses created. When an unfinished traditional clay piece inadvertently dries, paper clay and paper clay slip come to its rescue.

The example shown here is that of a coil-built clay pot.

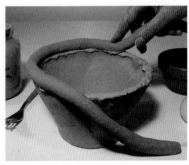

1 Dab the dry rim with a wet sponge until the surface softens, then score the softened surface deeply with a fork.

2 Brush on a thick layer of paper clay slip and allow it to build up some consistency.

3 Place a coil made of soft paper clay and attach by pushing the paper clay toward the base.

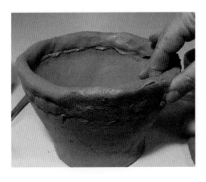

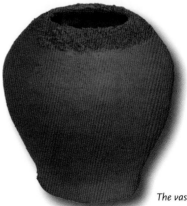

4 Continue building with paper clay coils, then smooth the entire surface of the vase with paper clay slip.

The vase after firing.

Quick paper clay slip recipe

Don't try to save paper clay slip; instead prepare a small amount when making a repair.

From wet paper clay: Take a small amount of wet paper clay and crush it between your fingers to increase its contact area and reduce its thickness. Lay it flat in a container and thoroughly wet the surface. Wait about one hour for the water to be absorbed. Mix.

Spread out the paper clay and let it soak up the water.

From a clay slip: If you are using clay without fiber and need to make a repair, fill a glass halfway with slip. Break up the fibers in a few sheets of toilet paper (about 3 g) by placing in a bowl of hot water. Drain. Mix the fibers obtained with the slip.

From dry paper clay: Keep a thin slab of paper clay with medium fiber content. You can take pieces as needed. Cover with water and let the paper clay soak for about fifteen minutes before using it.

Add the fibers to the slip.

The mixture of dry paper clay and water.

Finishing

All finishing techniques, tools, and materials used in ceramics are compatible with paper clay. For classic operations such as scraping, carving, or drilling, it is necessary to take the presence of fibers into account. The density of glazes and engobes must also be adjusted, as paper clay walls can be very absorbent.

Other finishing techniques, borrowed from various fields, can be applied to paper clay. Paints, varnishes, patinas, and pigments adhere to the pieces, whether they are fired or simply dried.

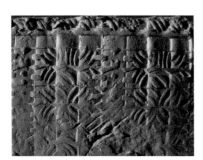

Surface marked by finely carved wood.

Impressions

Any object pressed against the surface of a wet paper clay makes its mark. Thus, a slab of paper clay spread on fabric retains the woven pattern. You will obtain the most precise impressions when the paper clay is leather hard.

Scraping

If you scrape the surface of paper clay with a serrated tool, the fibers will tear; this will blur the outcome of this process. The effect is more pronounced when there is a high percentage of long fibers and when the paper clay is dry.

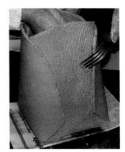

Scraping a wall with a fork.

Only by using paper clays with a low short-fiber content can a result close to the light scraping of a traditional clay be achieved. A deeper mark created by scraping a fork on a firm, moist surface is clearer. The bristly fibers on the surface are burned off during firing.

Smoothing

Smoothing with a rib.

Finishing an edge with a sponge.

A wet paper clay wall is smoothed with a metal rib or a plastic card. Start to even the surface by scraping off any roughness and filling in any hollows with paper clay slip or soft paper clay. Then move the tool along the wall to smooth it out. Close the angle between the wall and the tool so as not to tear the fibers.

Before smoothing, a dry wall requires that water be added to the surface, for example by spraying. A dry edge is smoothed with a wet sponge to remove ridges or roughness and soften the profile.

Polishing

Polishing the surface.

The polishing of a previously smoothed piece is done between the leather hard stage and the final drying. Rub the moist, firm surface of paper clay with the back of a spoon or a rubber rib. Repeat at various stages of drying until the surface becomes shiny. Applying wax, followed by buffing, will enhance the shine of a dry or fired piece.

Carving and Piercing

Any tool used on a paper clay surface, regardless of its moisture content, removes clay and brings out the fibers. To remove material with precision, fire at around 932°F (500°C). At this temperature, the fibers are consumed and the still soft clay can be removed with metal tools or a small precision drill. For porcelain paper clay this work can be done after a bisque firing at 1652°F (900°C); the pottery is soft enough.

Drilling on a paper clay shade with a cutter attached to a precision drill, after being fired at 932°F (500°C).

Applying an Engobe

Application of a porcelain paper engobe on traditional stoneware.

An engobe is a liquid slip made of clay and water that is traditionally applied to a leather hard clay wall to modify its color or to apply decoration. It can be colored by pigments or metallic oxides such as iron oxide. Apply the engobe to wet or dry paper clay after adjusting its dilution. It should not compact immediately upon contact.

The slip can contain 1 percent to 2 percent paper fibers. This allows it to adhere to any wall of clay, fibrous or not, wet or dry. Engobe is applied to whole pieces by dipping; decorative engobe patterns are applied with a brush. Then you can cover them if you wish with a transparent glaze.

Applying a Glaze

On traditional clay pieces, the glaze is applied after a first firing (bisque firing). This step hardens the clay to give it cohesion, preserves the porosity necessary for the adhesion of the glaze, and eliminates any risk of the glazed pieces exploding during the second firing (glaze firing). Thanks to its characteristics—good cohesion, high porosity, and low risk of exploding—glaze can be applied directly onto dry paper clay, which makes it possible to do only one firing. However, make sure that the surface of the paper clay is clean and free of dust and oils; otherwise, the glaze will be repelled during the firing.

If you opt for a **single firing**, it is best to apply the glaze with a brush or by spraying in several layers, letting it dry in between. Avoid dipping, especially if the walls are only a few millimeters thick, as they will absorb water from the glaze and soften.

If you do a **bisque firing** first, the walls will not soften, but you will have to take into account the high porosity of the pottery, which becomes higher with a higher fiber content. Dilute the glaze suspension with water to make it less viscous, or moisten the piece of pottery, which will limit its ability to absorb water. Dip, sprinkle, spray, or brush on the glaze.

Let your pieces air dry before firing, or program the kiln to preheat to less than 212°F (100°C).

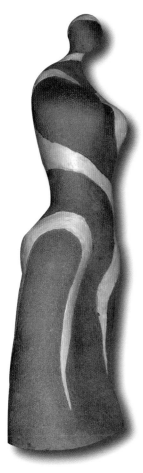

Woman, Jeanine Wolgensinger. Traditional stoneware with porcelain paper engobe, fired at 2336°F (1280°C).

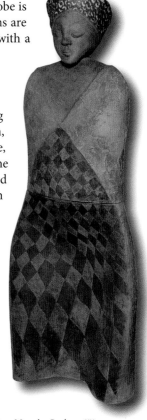

Mosaic, Barbara Wagner. Height 43 in. (110 cm). Fibered stoneware with cobalt oxide porcelain paper engobe. Fired in reduction at 2192°F (1200°C).

Glaze is applied with a brush.

Glaze is applied by dipping; the piece is held with a pair of tongs.

Glaze is applied by spraying.

White glaze, raku firing at 1832°F (1000°C).

Green glaze, fired in electric kiln at 2336°F (1280°C).

Orangish yellow glaze, raku firing at 1832°F (1000°C).

Blue glaze, fired in electric kiln at 2336°F (1280°C).

Red iron glaze, fired in electric kiln at 2336°F (1280°C).

Black glaze, fired in electric kiln at 2336°F (1280°C).

Other Finishes When Firing

All ceramic techniques—overglaze paint, polishes, etc.—which are explained in many books, can be applied to paper clay. Don't be hesitant to proceed as with traditional clay, because you are in fact working with clay when the fibers have burned up!

Underglaze paint must be diluted enough that is does not compact too quickly when applied. Use a thin brush to add decoration to a dry bisque-fired piece. Cover with a thin coat of transparent glaze and then fire.

Untitled, Wayne Fischer. Fibered porcelain with soft lines and curves highlighted by sandblasting of the glaze after firing. Dimensions 17.7 x 17 x 12 in. (45 x 43 x 30 cm).

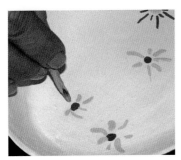

Apply underglaze paint with a thin brush.

The decoration, covered by a transparent glaze, after firing.

Metallic oxides and pigments suspended in water will become embedded in the smallest nooks and crannies of the irregular surface of an unsmoothed paper clay. To affect only the depressions, it is better to do a first firing beforehand so that the surface can be easily wiped afterward. A second firing is necessary to set the oxides.

1 Apply a suspension of manganese oxide.

2 Wipe off so it remains only in the depressions.

3 The surface structure is enhanced by applying a transparent glaze and firing at 1832°F (1000°C).

Crucibles, Carol Farrow. Height 20 cm. Impressions and paper clay surfaces enhanced with copper oxide set by firing in electric kiln at 2300°F (1260°C).

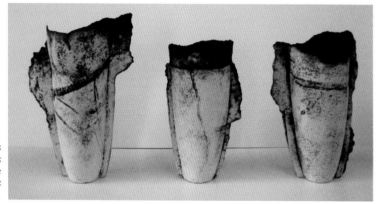

Other Finishes without Firing

The surface of a dry paper clay is compact and stiff. Its ability to grip both water-based and oil-based products makes it suitable for most decorative techniques: acrylic paint, gouache, cold ceramic paints, tinted waxes, etc. It is necessary to apply a protective varnish against water and humidity if the pieces that are simply dried may be exposed to the weather.

All these finishes are also possible on fired paper clay, regardless of the degree of firing.

Readers, installation by Elisabeth le Rétif. Height 23.5 in. (60 cm). The paper clay surface is treated differently for these two figures: a coat of soda for one, a spattering of "grès de Thiviers" (Thiviers stoneware) for the other. Raku type firing.

Apply acrylic paint with a round or flat brush.

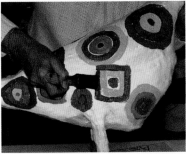
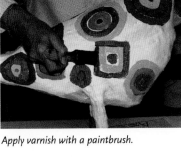

Apply varnish with a paintbrush.

If drying stresses cause cracks to appear, fix them before firing (see p. 100).

Apply a metallic wax with a paintbrush.

Polish the dry piece with a cloth.

Drying

The water content of a wet paper clay is higher than that of a traditional clay. It increases as the fiber content increases. This water is retained by the fibers in a cool environment and is easily released when it is hot. This is why we can accelerate the firming of a wall, if necessary, by using the heat of a hair dryer or a heat gun.

Drying in the Open Air

It is best if the paper clay dries naturally. Certainly do not keep pieces in a cool place and covered in plastic, as you would with traditional clay ones. Instead, let them dry in the open air after placing them on a folded sheet of newspaper. At room temperature, or about 68°F (20°C), allow about three days to dry completely.

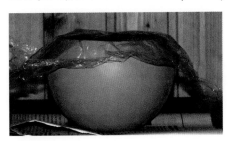

Drying of thin walls.

To prevent the **thin, even walls** of a cleanly shaped piece from warping as it dries, protect the edges with plastic (which helps regulate evaporation, as water from the edges normally evaporates faster) or dry it upside down.

A paper clay sculpture is air drying.

Drying of paper clay slabs.

The risk is the same with **slabs** a few millimeters (about 1/8 in.) thick. Water from the edges evaporates more quickly and the plate deforms. For an even evaporation, place the slab between two wooden boards for a few days, making sure that it does not stick to them.

Accelerated Drying

It is possible to accelerate the drying of pieces with walls not more than 0.2 in. (1.5 cm) thick. Put them in a convection oven at 122°F (50°C), leaving the door ajar. It is important to stay far from the boiling point of water (212°F/100°C). Turn the pieces from time to time. Complete drying will take only one to two hours.

Firing

For commercial paper clay, follow the firing temperature indicated by the manufacturer. A paper clay prepared in your studio will be fired at the same temperature as if the clay had not received fibers, as overall it retains its properties.

The fibers will burn up from 446°F (230°C) up to 752 to 842°F (400–450°C), giving off smoke and a burning smell that can be troublesome if the paper content is high. The ventilation flap of the kiln must remain open until 932°F (500°C) in order to evacuate the fumes produced by the paper and to prevent their fine particles from being deposited in the kiln, thus reducing the life of the heating elements if it is electric. As for any firing, the room must have good ventilation or air extraction. It is best to avoid staying near a kiln in operation, as the fumes from the combustion of the various residues contained in the clay or glaze can be toxic.

For even walls a few millimeters (about ⅛ in.) thick, plan to preheat at 176°F (80°C) for one hour if it is necessary to diminish any traces of moisture. On the other hand, it is essential that thick walls or solid pieces are perfectly dry before firing; otherwise, they will burst by laminating (typical of paper clay, which releases water in layers).

Firing in a Studio Kiln

Electric kiln.

In an electric or gas kiln, you can mix paper clay and traditional clay pieces.

During a bisque firing, the paper clay piece hardens, but remains fragile and crumbly, especially in the case of porcelain. Increase the temperature by at least 212°F (100°C) to increase its solidity. After the glaze is applied, do the second firing as for traditional clay pieces. Take great care putting them in the kiln when firing at the maturing temperature of the clay. With paper clay, you may have made larger and thinner pieces, which may warp or bend. So allow enough clearance around a slender piece that feels light: prop it up or reduce the firing temperature.

Single Firing in a Studio Kiln

We have seen that with paper clay, it is possible to do a single firing. After placing the glaze directly on the dry pieces, they are simply placed in a kiln for a single firing.

The risk of exploding due to an air inclusion is almost nil when the paper clay contains at least 3 percent of fibers or a mixture of fibers and grog. Indeed, the porosity created by the combustion of the fibers will absorb the air pressure caused by the heating (which can cause traditional clay pieces to explode).

Make sure that the pieces are completely dry before firing. If necessary, preheat below 212°F (100°C) and ventilate the kiln. Program the kiln to heat up at 212°F (100°C) per hour for five to six hours and keep the kiln's ventilation flap open during this first phase. Once the quartz inversion happens—around 1058°F (570°C)—the kiln can be operated at full power with the flap closed until the final temperature required for the glaze to melt is reached. Make sure that the temperature does not exceed the maturation temperature of the clay.

Raku Firing

Raku firing in an open-air kiln, using wood or gas, is best suited for paper clays with a medium to high fiber content (or low fiber content with the addition of grog). They will behave like heavily grogged clays.

Raku firing can be done in one hour if you have prepared the pieces accordingly. Do a first bisque firing in an electric or gas kiln, apply the glaze, and let the pieces dry completely before placing them in the raku kiln. This way, you can do a series of firings without waiting for the kiln to cool down. In the case of porcelain paper clay or stoneware paper clay, it is best to strengthen the pottery by pre-firing at 2012°F (1100°C).

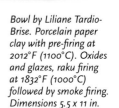

A glazed piece that is not bisque fired will withstand a single raku firing if it is put in the kiln completely dry and if the temperature rise at the beginning of the firing is well controlled. Place the pieces in the cold kiln and spread the heating out over one hour before reaching 932°F (500°C). If you do successive firings, let the temperature of the kiln drop; a raw piece placed on a kiln tray at 932°F (500°C) will burst.

Once out of the kiln, the paper clay cools quickly. Smoke it immediately by placing it in sawdust if you want an intense black.

Single raku firing is an excellent solution for short courses or workshops because it allows you to finish the pieces quickly. If you are really in a hurry, accelerated drying (see p. 110) allows you to make a piece within a day. Here are the steps for making a small bowl using a variation of this technique.

Bowl by Liliane Tardio-Brise. Porcelain paper clay with pre-firing at 2012°F (1100°C). Oxides and glazes, raku firing at 1832°F (1000°C) followed by smoke firing. Dimensions 5.5 x 11 in. (14 x 28 cm).

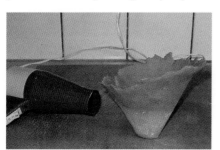

1 Form a small bowl by rolling up a slab of paper clay and drying it with a hair dryer.

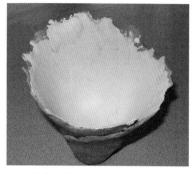

2 Apply the glaze and let air dry for a few hours.

3 Place in the raku kiln to be fired about two hours.

4 Place the piece in a smoking box containing sawdust, cover, and wait thirty minutes before removing.

Small bowl made in less than twelve hours.

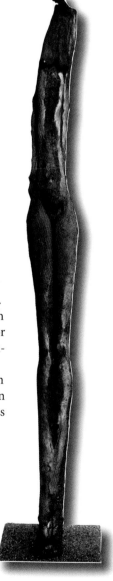

Modular, Adjustable Kiln

Paper clay makes it possible to create large pieces that are both easy to handle and portable, and for which workshop kilns are often too narrow or not high enough. It is then necessary to build a kiln that is a suitable size for the piece. The chamber of such a kiln can be built with ceramic fiber board assembled on metal grids or mesh or with aerated concrete blocks if the temperature does not exceed 2012°F (1100°C).

As in a raku kiln, the piece will be protected from direct contact with the flame. The increase in temperature will be handled by one or two gas burners.

*The firing of **Tisiphone**, followed by smoke firing, required the construction of a horizontal kiln all around the work by Nina Seita.*

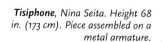

***Tisiphone**, Nina Seita. Height 68 in. (173 cm). Piece assembled on a metal armature.*

Alternative Firing Methods

Thanks to its porosity, paper clay, whether grogged or not, has a high resistance to thermal shocks. It is therefore suitable for many cooking methods, even if the temperature rise is rapid or difficult to control.

Firing Over an Open Fire

If you are firing just on the ground or in a hole in the ground, fill and completely surround the completely dry pieces with fuel such as wood or coal. Avoid empty spaces that would put the pieces in direct contact with the flames at the beginning of the firing, which would cause splinters on the surface.

The temperature reached will be sufficient to harden the pieces, but it will be difficult to exceed 1472°F (800°C), unless you have large quantities of fuel ready.

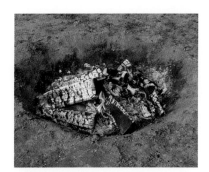

Firing on the ground.

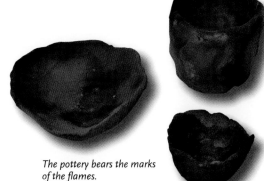

The pottery bears the marks of the flames.

Closed Wood-Fire Kilns

There are many variations of closed wood-fire kilns (tunnel kilns, anagama kilns, etc.) suitable for paper clay. Their temperature reaches 1832°F (1000°C) and more.

The paper kiln, with its shell made of successive layers of glossy paper and clay slip placed on a wire mesh surrounding the pieces and the fuel, is a variant of this type of firing. It is quite possible to make this shell with thick paper clay slip placed on the wire mesh wrapped with glossy paper.

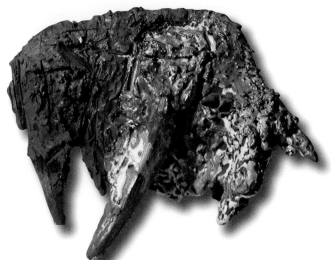

***Bull** (Stier), Otakar Sliva. Height 8 in. (20 cm). Stoneware and porcelain with moderate amount of fiber and heavily grogged. Fired in an anagama kiln, 2372°F (1300°C) reached in four days. Photo by H. Schmeltz.*

Part II Paper Clay Projects

Mosaic

Antelope

Platter

Statuette

Box

Prehistoric
Animal

Cat

Rooster

Body Cast

Giraffe

Mosaic

When making a mosaic, paper clay serves both as a backing material and a joint. During drying, shrinkage keeps the mosaic tiles in place, the resistance to contraction prevents the formation of cracks, and the cohesion of the whole makes firing unnecessary.

The step-by-step instructions in this section explain in detail how to create paper clay projects that wouldn't be possible to make with traditional clay. They are presented in order of increasing difficulty.

Techniques Used

- Slab construction
- Embedding

Supplies

- A few earthenware tiles
- 1 tile cutter (tiler's tool)
- 1 small hammer
- Protective goggles
- 3.3 lbs (1.5 kg) of white paper clay with medium fiber content
- 2 pieces of particle board about 16 x 20 in. (40 x 50 cm)
- 1 rolling pin
- 2 laths 0.4 in. (1 cm) thick
- 1 tile or an 8 x 8 in. (20 x 20 cm) piece of paper
- 1 knife
- 1 container
- 1.5 oz. (4 cl) water
- 1 toothpick
- 1 sheet of newspaper
- 1 sponge
- 1 indented hanger (for pouring plaster)

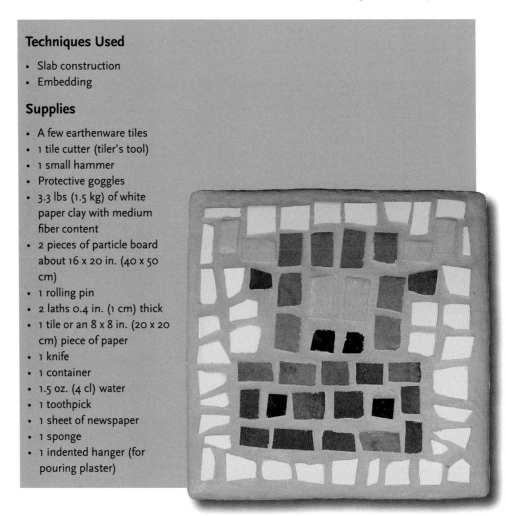

The "moo-moo" by Floraine Maehr. Unfired.

1 With the tile cutter, cut the earthenware tiles into strips about ½ in. (1 cm) wide.

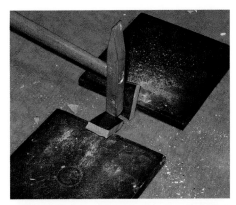

2 Place the strips across two tiles separated by at least the width of the hammer. Put on protective goggles in case of any flying fragments. Give it one good sharp hit to break the tile strip. Continue in this manner to make mosaic tiles of different shapes and sizes.

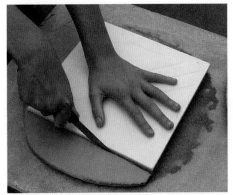

3 Prepare a paper clay slab 0.4 in. (1 cm) thick (see technique on p. 67). With the knife, cut out an 8 in. (20 cm) square using the tile or the paper as a template.

4 Put into a container about 7 oz. (200 g) of paper clay, squeezing it between your fingers and adding 1.35 oz. (4 cl) of water. Let the water seep in, then mix to form a very soft paper clay.

5 Draw a design directly on the paper clay slab using the toothpick.

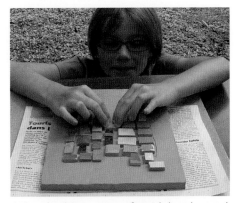

6 Place the slab on a piece of particle board covered with newspaper. Make a design with the broken tiles and push them about halfway into the paper clay. Then do the same with the white background mosaic tiles.

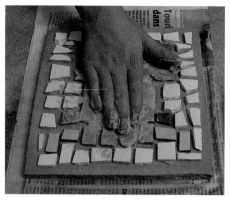 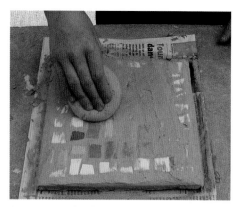

7 Fill in the space between the tiles by spreading the very soft paper clay over the entire surface. Finish by rounding the edges. Let air dry for a few hours for the surface to firm up.

8 Once again level out the surface with very soft paper clay and let it firm up. Then clean the mosaic tiles with a wet sponge.

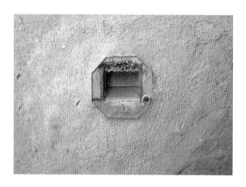

9 Turn the slab over and identify the hanger location. Push it into the clay and add very soft paper clay all around it so it is properly attached.

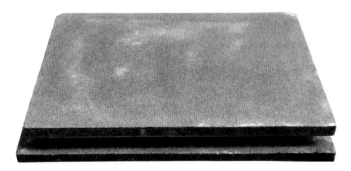

10 Place the mosaic between two pieces of particle board in contact with portions of dry surfaces. Turn the fiberboard over periodically to help it dry out.

If you make a larger mosaic, let it dry between two pieces of grating to facilitate air circulation. Weight it on top to force a flat, even surface.

Variation: Glass Mosaic Tiles

Choose tiles ¼ to ¾ in. (1 to 2 cm) wide and a few millimeters thick. You will use them as is or cut them with mosaic nippers. More expensive than simple earthenware tiles, they result in an outstanding piece. You will find them in specialized craft stores.

Platter

This decorative dish can be kept perfectly flat by assembling the four elements that make it up when they are dry. In raku firing, the thermal shocks from taking it out of the kiln and smoke firing it do not affect the solidity of the feet joins.

Techniques Used

- Slab construction
- Coil construction
- Dry on dry assembly
- Glazing
- Electric kiln and raku firing
- Smoke firing

Supplies

- 3.3 lbs. (1.5 kg) of white paper clay with medium fiber content
- 1 wooden board
- 1 rolling pin
- 2 laths about ¼ in. (6 mm) thick
- 1 knife
- 1 bowl of water
- 1 sponge
- 1 bowl of paper clay slip (7 oz./200 g of paper clay + 4¼ oz./120 g water)
- 1 flat brush
- About 3.4 oz. (10 cl) green raku glaze to apply with brush
- For the raku firing: kiln, tongs, gloves, smoking container, sawdust

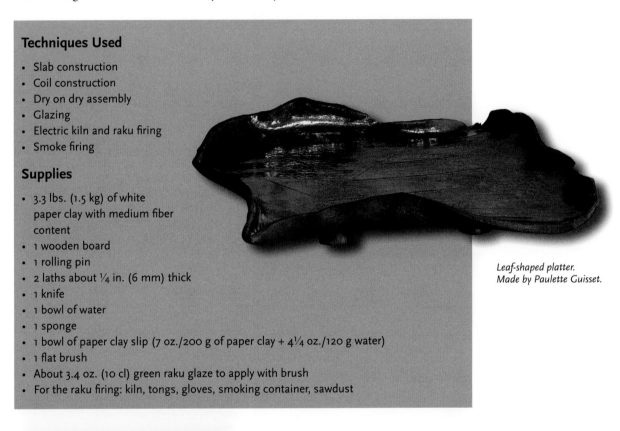

Leaf-shaped platter.
Made by Paulette Guisset.

1 Prepare a paper clay slab about ¼ in. (6 mm) thick (see technique on p. 67). Place the slab on a dry board and smooth it one last time with the rolling pin. Cut it into a leaf shape with the knife and draw the veins. Turn up the edges of the leaf to give the platter some depth.

2 Roll a piece of paper clay on the table to form a thick coil and cut segments of the same length to make three feet.

Paper clay lightens as it dries. It is completely dry when it no longer feels at all cold to the touch.

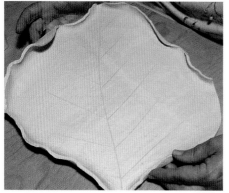

3 Let the components dry for two to three days in the open air. To check that the dish is not sticking to the board, push it sideways (it is better not to lift it until completely dry).

It is not necessary to wet a large area of paper clay to attach the legs to this dish. It is also unnecessary to wet the entire thickness of the paper clay.

4 Turn over the platter and dab the areas where the feet will be attached with a wet sponge, until the surface of the paper clay is softened. Dip the feet halfway into the water for one to two minutes, then score the wet surfaces of the leaf and the feet with a knife.

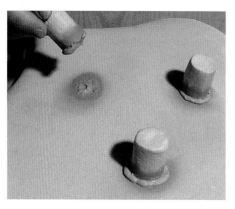

5 Apply a thick layer of paper clay slip to the areas to be joined, then place the feet and press moderately to adhere. Then spread paper clay slip around the join.

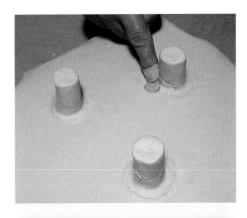

6 Let dry for twenty-four hours in the open air, then moisten and apply paper clay slip to the small cracks that appear at the join. Press and smooth with your finger, then let dry.

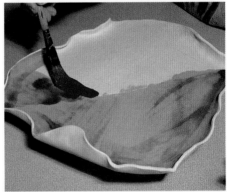

7 Bisque fire at 1832°F (1000°C) in an electric kiln. Moisten the inside surface of the platter, and apply the glaze with a brush.

The bisque firing is not necessary; the glaze can be applied directly on the dry paper clay. The temperature of the raku kiln should then be increased more gradually.

8 Place the platter in the raku kiln and heat until the glaze melts, about one hour.

9 Remove the dish from the kiln with a long pair of tongs and a heat shield for your hands, place it in the sawdust, cover it with sawdust, and then close the smoking container. Wait about thirty minutes, then remove the platter and immerse it in water.

Immediately smoke firing the piece after removing it from the kiln results in an intense black color on the unglazed parts and brings out copper highlights on a glaze containing copper oxide.

Box

A sheet of dry porcelain paper is used as a base for the construction of this box. The cohesion brought by the fibers makes it possible to cut, manipulate, and assemble the different dry elements.

Techniques Used

- Slab construction
- Dry on dry assembly
- Underglaze painting
- Glazing
- Electric kiln firing

Supplies

- 1 large wash basin
- 1.5 oz. (40 g) of toilet paper (about two-thirds of a roll)
- 2 quarts (2 liters) of hot water to prepare a paper clay slip
- 1 kitchen whisk
- 1 dust mask
- 4.4 lbs. (2 kg) of porcelain powder
- 2 small bowls
- 1 plaster tile
- 3 laths about ¼ in. (6 mm) thick
- 1 board
- 1 knife
- 1 square of thin fabric
- 1 flat paintbrush
- 1 pencil
- 1 sponge
- 1 thin paintbrush
- 1 small jar of underglaze paint, yellow
- 1 small jar of underglaze paint, blue
- 1.7 oz. (5 cl) of transparent porcelain glaze

Porcelain box,
painted and then glazed.
Made by Jocelyne Nargues.

1 Unroll the toilet paper in the wash basin and add 2 quarts of hot water. After a few minutes, mix with a whisk to homogenize.

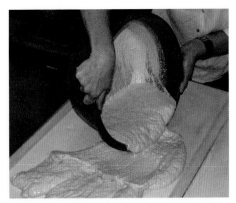

2 Put on a dust mask before adding the porcelain powder. Wait until it is has soaked up the water, then mix to obtain the paper clay slip. Reserve a small amount of slip in a wash basin. Pour the rest between two laths placed on a plaster tile to form a large slab (see technique on p. 68).

3 Deeply score the dry slab along its entire length, about 6 in. (15 cm) from the edge, running the knife along a lath.

4 Fold the strip over the edge of the work surface and carefully separate it. From this strip, cut the walls (1.1 to 4.7 in.; 3 to 12 cm wide) in the same way.

5 Dunk one side of the first wall in water for ten seconds. Do the same with a second one.

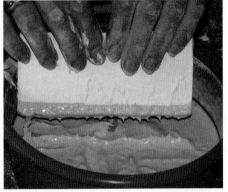

6 Dip the moistened parts in the reserved paper clay slip.

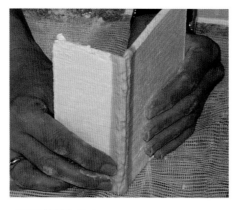

7 Place a cloth on the work surface to avoid sticking, and join together the first two walls. While the slip is still shiny, place the two edges against each other. Hold in place without moving until the slip sets.

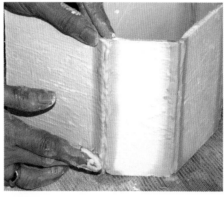

8 Repeat this procedure to assemble the other edges of the box. Use a brush to moisten and coat the edges already in place with paper clay slip. Smooth the join, without being too fussy, to distribute the slip. When all sides are joined together, let stand for one hour or use a hair dryer to firm up the joins.

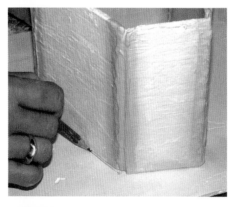

9 Place these joined walls on the large slab. Mark the outline of the base with a pencil and cut it with a knife. Moisten all contact areas and coat with paper clay slip before joining the edges as before.

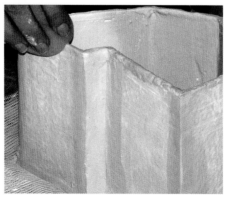

10 Prepare soft porcelain paper clay by pouring paper clay slip on the plaster to remove water. Use it to reinforce all joined edges. Smooth edges with a sponge and scrape out irregularities with a knife.

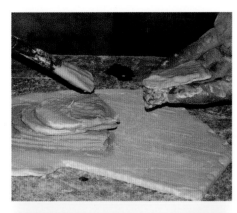

11 Cut the cover from the slab as well as the pieces for the handle. One at a time, moisten the contact surfaces, coat them with paper clay slip, and place them in position.

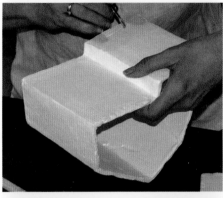

12 Allow the box to dry, then fire it at 1832°F (1000°C) to harden the porcelain and facilitate application of the finish. Remove any dust from the piece and moisten it, then apply the underglaze paint decoration with a thin brush.

13 Put on the dust mask and spray a thin layer of transparent glaze on the inside and outside of the box and on the top of the lid. Glaze fire the piece at 2336°F (1280°C).

Tip: Sand firing

Place the box and lid separately on sand. The porcelain will shrink by sliding evenly in the last phase of the firing, thus avoiding deformation. Make sure that the sand used does not melt at the final temperature (2336°F [1280°C]). Sand for small animals (birds, hamsters, etc.), for example, has a high melting point. It is best to do a test run first.

Cat

The technique of dry on dry assembly is well suited for the assembly of this big cat with spindly legs. Its colorful finish illustrates the diversity of possible decorations.

Techniques Used

- Pinch building
- Wet on wet assembly
- Dry on dry assembly
- Glazing
- Overglaze and underglaze painting
- Electric kiln firing

Supplies

- 3.3 lbs. (1.5 kg) of grogged paper clay with medium fiber content
- 1 Styrofoam ball cut in half
- 1 pair of used pantyhose or tights
- 1 knife
- 1 hair dryer
- 1 bowl of paper clay slip (7 oz./200 g of paper clay + 4.25 oz./120 g water)
- 1 flat paintbrush
- 1 wooden spatula
- 1 drill bit
- 1 curved tool
- 1 small washbasin
- Plastic food wrap
- 1 ceramic tile
- 1 round paintbrush
- About 1.7 oz. (5 cl) of red earthenware glaze to apply with a brush
- Overglaze and underglaze paints (white, yellow, green, lilac, blue, and black)
- About 3.4 oz. (10 cl) transparent earthenware glaze
- 1 gold waterproof marker
- 12 in. (30 cm) of string
- 1 roll of florist's wire

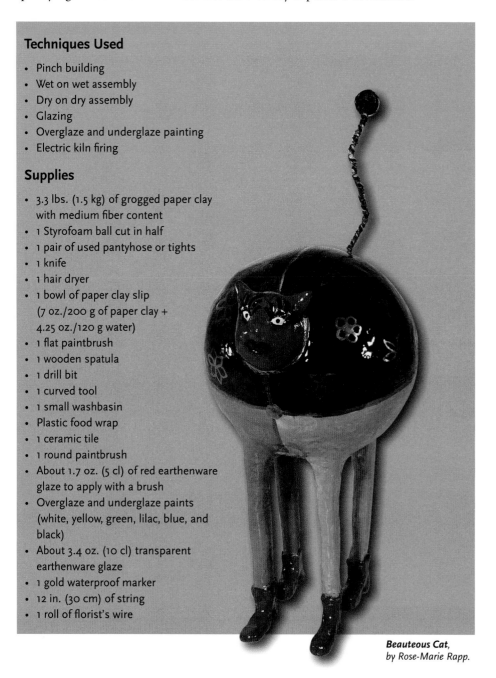

Beauteous Cat,
by Rose-Marie Rapp.

1 Flatten two balls of paper clay with the palm of your hand to form patties less than 0.4 in. (1 cm) thick. Mold one patty on a half Styrofoam ball covered with pantyhose or tights, then cut off the excess clay with a knife.

2 Use a hair dryer to firm up the paper clay. Unmold it by pulling on the fabric. Repeat this process for the second half.

3 Place a coil of paper clay on the inside edge of one of the half balls and brush all surfaces to be joined with paper clay slip.

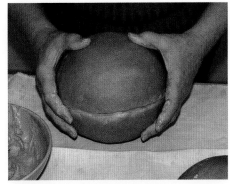

4 Press the two body halves together and smooth the join with your fingers. Fill in depressions in the resulting ball with paper clay. Smooth out the bumps by tapping with a spatula. Drill an opening where the tail will be.

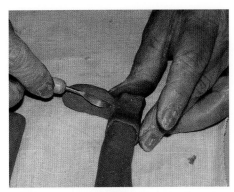

5 Mold the cat's head and mark details with a pointed tool. Mold the legs, adjusting the top to the curvature of the body, and add the boots. Let dry for two or three days in the open air.

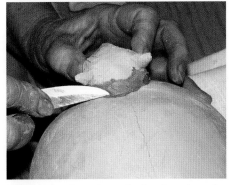

6 With a brush, moisten the location where the head will go on the body. Dip the bottom of the head in water. Score wet surfaces. Coat contact surfaces with paper clay slip. Attach the head to the body.

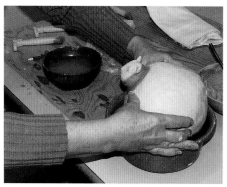

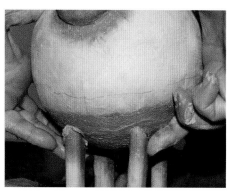

7 Soak the cat's belly in a small bowl of water for about one minute. Soak the top of the legs as well. Score the wet surfaces with a knife and coat them with paper clay slip.

8 Surround the boots with plastic food wrap and stabilize them on a tile with some paper clay. Put the body in place. Reinforce the top of the legs by adding some paper clay. Firm up the assembled piece with a hair dryer before releasing the cat from the tile. Let dry and then fire at 1832°F (1000°C).

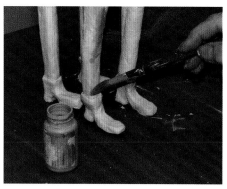

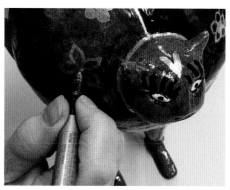

9 Moisten the entire clay surface and apply two coats of red glaze to the head and boots. Paint on the glaze, then finish by spraying a thin layer of transparent glaze on the whole piece. Do a glaze firing at 1832°F (1000°C).

10 Finish decorating the cat with the gold marker. Tightly wrap the string with wire and put the tail in place.

Various finishes

The colorful decoration of this cat can be done in various ways, whether the clay is fired or not. For example, cover it with earthenware glazes or decorate with overglaze paint before firing the glaze. If you don't have a kiln, apply cold ceramic paints that cling well to the paper clay.

Body Casting

The impression from plaster strips makes it possible to create a light mold that accurately reproduces the skin grain and texture of a fabric on a cast made by brushing on thick paper clay slip. The fibers bring the cohesion needed for this process.

Techniques Used

- Brushing
- Single firing

Supplies

- 2 rolls of medical grade plaster gauze bandage 4 in. (10 cm) wide
- 1 pair of scissors
- 1 washbasin
- Vaseline
- 1 oz. (30 g) of toilet paper (about half of a roll)
- about 3 cups (¾ liter) of hot water to prepare a thick paper clay slip
- 1 whisk
- 1 dust mask
- 2.2 lbs. (1 kg) porcelain powder
- Rags
- Plastic bubble wrap
- 1 wide, flat paintbrush
- 1 pointed, curved tool
- Plastic food wrap

Cast on body and lace, made by Sylvie Hug and Chantal Muller.

When taking the impression, pay attention to your model. Explain the steps involved in taking the impression, the cold sensation when the plaster strips are applied, the tugging when the plaster sets, etc. Prepare all the material beforehand so that the session is as short as possible.

1 Cut strips of the plaster bandage 4 and 8 in. (10 and 20 cm) in length.

2 Ask the model to put a thin layer of Vaseline on her skin. Also coat the lace made of synthetic fabric. The Vaseline will protect the skin and make it easier to remove the mold.

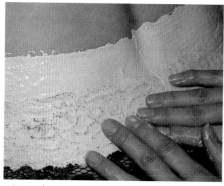

3 Dip a plaster strip in water and remove it as soon as it softens. Place short strips of plaster on the skin and fabric, overlapping them by 0.4 in. (1 cm). Smooth each strip with your fingers to avoid wrinkles. Work in rows to cover the entire area to be part of the cast.

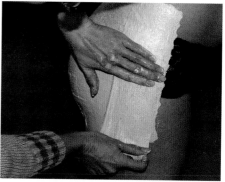

4 Apply a second layer of long strips crossing the first. Then apply a third layer in the same direction as the first. Ask the model to remain still for five to ten minutes, until the plaster sets.

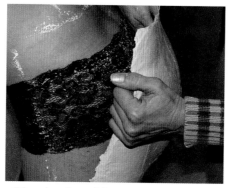

5 When the edges of the plaster come away from the skin, gently remove the mold and let it dry.

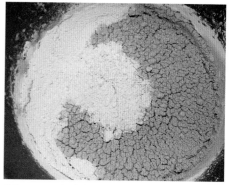

6 Prepare a thick, homogeneous paper clay slip in the same way as for the box (see p. 123). As this preparation contains little water, it takes about two hours for the porcelain powder to soak in completely. Then mix.

7 Place the mold vertically. To level it, cut the base with scissors if necessary.

8 Place the mold firmly on a bed of rags and bubble wrap. Brush the inside with thick paper clay slip using a wide brush. Carefully spread this first layer, which will pick up all the details of the impression, then apply a second layer that goes across the first. Wait for the whole piece to air dry until firm. Alternate applying the slip and letting it firm up until the slip is gone.

9 Let firm up in the open air. Separate the porcelain from the plaster on the edges with a pointed, curved tool, then wrap the edges with plastic food wrap to slow down the drying process.

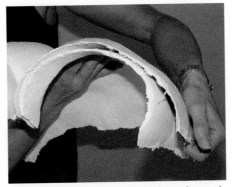

10 Unmold after it is completely dry and smooth the surface of the porcelain paper with dry fingers to remove any irregularities due to air bubbles remaining in the plaster mold. Smooth the edges of the cast with a wet finger. Then fire, but do not exceed 2012°F (1100°C) to limit shrinkage and deformation.

Antelope

This tall, stylized antelope requires an armature. It gives the clay something to hold onto when building and reinforces it once dry. This work on wire is made possible by the presence of fibers, which bring cohesion to the clay. This large, slender, and elongated piece is not intended for firing.

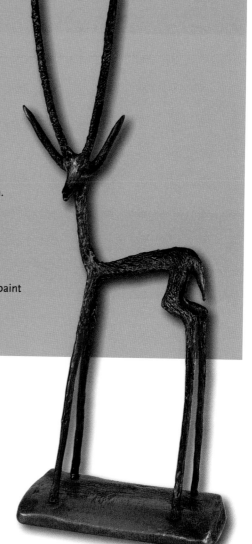

Techniques Used

- Armature
- Dry on dry assembly
- Patinas

Supplies

- 1 vise
- 5.5 yds. (5 m) of 0.06 in. (1.5 mm) galvanized wire
- 1 wire cutter
- 1 small pair of bent nose pliers
- 1 small pair of round nose pliers
- 1 sheet of polystyrene about 12 x 8 x 2 in. (30 x 20 x 5 cm)
- 1.3 lbs. (600 g) of white paper clay with medium fiber content
- 1 sponge
- 1 fork
- 1 small container of matte black acrylic paint
- 1 flat paintbrush
- A bit of antique bronze wax
- 1 rag

Antelope, height 23.5 in. (60 cm), paper clay with patina finish. Unfired piece by Liliane Tardio-Brise.

1 Cut five pieces of wire 31.5 in. (80 cm) long and place them side by side in a vise. Let 12 in. (30 cm) of the two wires to be used for the antelope's back legs hang out the bottom.

2 Braid the wires to start to shape the body.

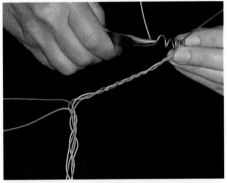

3 Separate the two wires for the front legs and twist the three other wires at a right angle. Braid the neck. With one of the wires, shape the head in a spiral using a small pair of pliers.

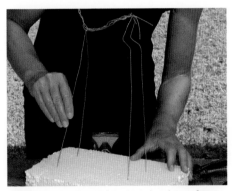

4 Poke the antelope's legs into the sheet of Styrofoam to hold it upright.

5 Adjust the lengths of the wires with the wire cutter. Add a piece of wire to form the ears. The metal armature must be adjusted as best as possible at this point as you will not be able to change its shape after adding the paper clay.

6 Cover the straight parts of the armature with small pieces of paper clay. Do not cover the ends, and allow the clay to have some play with the wire. Let dry for forty-eight hours in the open air to allow for shrinkage.

7 Soften the ends of the sections with a wet sponge and add paper clay until the antelope is completely covered.

8 Soften a bit of paper clay with water and brush the entire surface of the antelope with this soft paper clay. Scrape with a fork to give it texture. Allow to dry completely.

9 Cover the antelope with acrylic paint with a flat brush. Finally, apply wax with a cloth, let dry twenty-four hours, and polish.

A paper clay stand

After finishing, cut the wires that protrude from the legs or save them to be inserted into a paper clay stand. The openings made in the stand when making the antelope must take into account a drying shrinkage of approximately 5 percent. Once dry, the stand receives a patina finish made of yellow ochre acrylic paint and bronze wax.

Statuette

On a pedestal or planted in a garden, this willowy statuette with spindly legs is held together by steel rods. Applied to a metal armature, the paper clay is worked to varying degrees of firmness.

Techniques Used

- Slab construction
- Armature
- Wet on wet assembly
- Wet on dry assembly
- Pinch building
- Glazing
- Electric kiln firing
- Smoke firing

Supplies

- 7.7 lbs. (3.5 kg) of white paper clay with medium fiber content
- 1 piece of burlap 24 x 24 in. (60 x 60 cm)
- 1 rolling pin
- 1 knife
- 2 stainless steel threaded rods 0.16 in. (4 mm) in diameter and 20 in. (50 cm) long
- 1 ribbon tool
- 1 board
- 4 sheets of paper toweling
- 1 bowl of soft paper clay (7 oz./200 g of paper clay + 0.7 oz./ 20 g water)
- 1 wood modeling tool
- 1 stainless steel threaded rod 6 in. (15 cm) long
- 1 pair size 10 (6 mm) knitting needles
- 1 sponge
- 1 bowl of paper clay slip (100 g of paper clay + 60 g water)
- 1 small wood modeling tool
- 1 piece netting 8 x 24 in. (20 x 60 cm)
- 2 laths 0.12 in. (3 mm) thick
- 1 flat paintbrush
- 0.35 oz. (10 g) magnesium dioxide
- 1 pair disposable gloves
- 1 old sponge
- About 3.4 oz. (10 cl) orange earthenware glaze to be applied with a brush
- About 2 tsp. (1 cl) red earthenware glaze to be applied with a brush
- 13 gallons (50 liters) of sawdust
- 1 garden incinerator

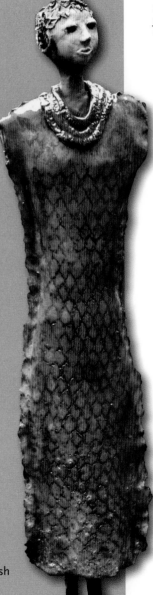

Glazed, smoke-fired figure. By Paulette Guisset.

1 With the rolling pin, roll out 4.4 lbs. (2 kg) of paper clay on the burlap to make a 0.75 in. (2 cm) thick slab. Cut out a silhouette 12 in. (30 cm) long with a knife.

2 Place the metal rods parallel to each other, letting them stick out about 8 in. (20 cm) at the bottom. Press to mark their locations.

3 Remove the rods and hollow out their impressions with a ribbon tool.

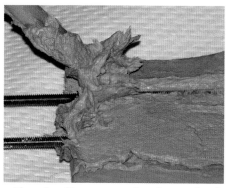

4 Place the silhouette on a board covered with paper. Cover the rods in soft paper clay using the wood modeling tool.

5 Push the small rod into the upper part and let it stick out about 2.75 in. (7 cm). Let it air dry for a few days.

6 Hit 3.3 lbs. (1.5 kg) of paper clay against the work surface to shape it. Make a base that will hold the statuette when it is being dressed and fired. Space the knitting needles like the steel rods and push them in vertically about 4 in. (10 cm). Remove them and let air dry for a few days.

7 Remoisten the silhouette and apply soft paper clay to fill in depressions and cracks. Shape a stomach and breasts, then let the piece firm up.

8 Place the figure on the dry base. Wet the lower body for the leg assembly. Shape the legs from two flattened coils and wrap them around the stems. Weld to the body with paper clay slip, then shape the feet.

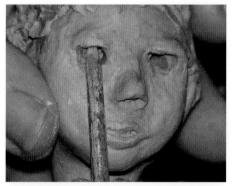

9 Shape the head from a small ball of paper clay. Work on the eyelids with a wood modeling tool and on the hair with a knife.

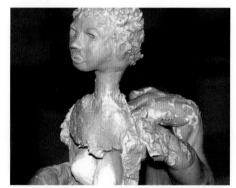

10 Wet the upper body and coat it with slip. Place the head on its rod and carefully join together. Brush with soft paper clay and allow to firm up.

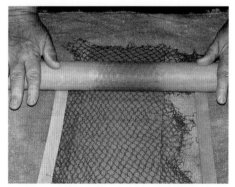

11 Roll out two 0.12 in. (3 mm) thick slabs for the dress. Place a net on top and press over it with the rolling pin to make an impression with the netting. Let air dry for thirty minutes or use a hair dryer to firm up.

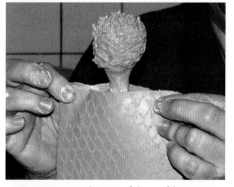

12 Cut two rectangles out of these "fabrics." Coat one of them across the top width with paper clay slip. Put them in place and press to secure the dress at the shoulders.

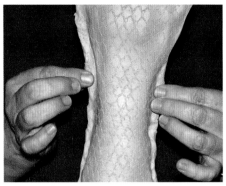

13 Place paper clay slip along the lengths, and pinch to weld the two sides of the dress. Adjust and finish. Allow to air dry, then bisque fire.

14 Put on gloves. Mix 0.35 oz. (10 g) of manganese dioxide with about 3.4 oz. (10 cl) of water. Apply to the hardened clay with a brush.

15 Wipe the dress and collar with an old sponge to leave the manganese in the depressions only.

To keep the statuette standing vertically on its base, you can place the head near the kiln plates.

16 Put the statue back on its base and apply the red glaze on the necklace and the orange glaze on the dress with a brush. Place in the kiln, making sure that the statuette is placed vertically, and is stable and balanced, as the steel rods can bend in the oven. Fire at 1832°F (1000°C).

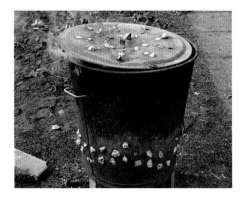

If you want the statuette to stay on its base, shorten the rods. Smoke fire the base with the statuette.

17 Place the statuette in an incinerator and surround it with sawdust. Poke some crushed paper balls into the sawdust and light them on fire. When the sawdust starts to burn, put the lid on and let it burn for twenty-four hours. The smoke stream can be regulated somewhat by plugging the incinerator holes with aluminum foil.

Prehistoric Animal

The solution to creating a large, tall animal with a big body and a slender neck is found by covering a wire frame with a mixture of clay and fibers. A few millimeters thick, and thus very light, the whole piece receives a patina once dry.

Techniques Used

- Armature
- Patina

Supplies

- 1 roll of chicken wire 20 in. (50 cm) wide
- 1 wire cutter
- 1 yard (1 m) of 0.027 in. (0.7 mm) galvanized wire
- 1 small pair of bent nose pliers
- 12 in. (30 cm) of floral wire netting 20 in. (50 cm) wide
- 1 small pair of round nose pliers
- 9.9 lbs. (4.5 kg) of white paper clay with medium fiber content mixed with 6.25 cups (1.5 liters) of water in a pail
- 1 spatula
- 1 flat wide paintbrush
- 1 magazine with glossy paper
- 1 pair disposable gloves
- 1 container of matte black acrylic paint
- 1 container emerald green cerusing wax
- 1 small brush with stiff bristles
- 1 rag
- 1 small bottle blonde bronze base coat

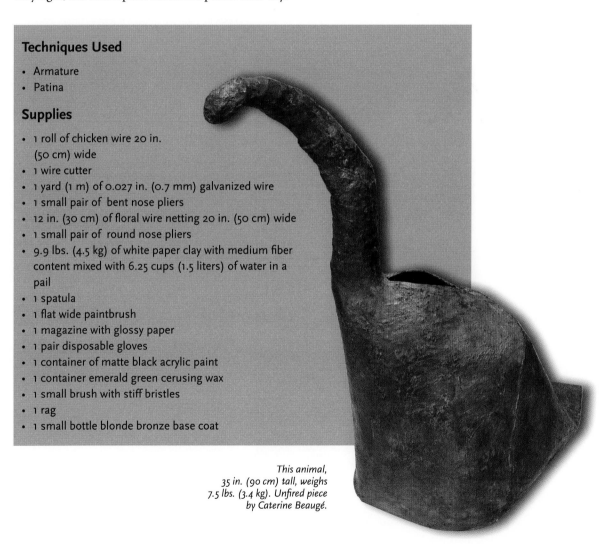

This animal,
35 in. (90 cm) tall, weighs
7.5 lbs. (3.4 kg). Unfired piece
by Caterine Beaugé.

1 Shape chicken wire to form the body of the animal.

2 Use pieces of wire twisted with a small pair of bent nose pliers to hold the shaped chicken wire, then separate the body from the rest of the roll of wire by cutting it off with the wire cutter.

3 Cut and roll up the floral wire netting, overlapping the edges, forming the neck. Hold it together by twisting the cut wires. Curl the ends toward the inside of the body.

4 Put the neck in place and secure it with small pieces of wire.

5 Form the head with the floral wire netting and attach it to the neck.

6 Using a brush, spread a very thick paper clay slip on sheets of glossy paper.

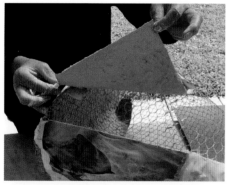

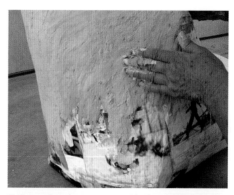

7 Place the coated glossy paper slip against the mesh. The paper clay should hold onto the mesh and the sheets of paper should overlap. Cover all of the wire mesh.

8 Cover the glossy paper with the remaining very thick paper clay slip by spreading it with your hands. Let it dry completely in the open air for at least forty-eight hours. The structure is then solid and can be handled easily.

9 Brush the entire surface of the paper clay with diluted black acrylic paint, then let dry for one hour.

10 Apply wax polish by dabbing with a small stiff brush and a cloth. Let dry overnight, then rub vigorously to shine.

11 Apply bronze liquid in circular motions. Allow to dry, then rub again to reveal a beautiful patina surface.

Successful mixing

Your mixture of paper clay and water should form a very thick and homogeneous paper clay slip. If you have a powerful mixer, mixing is both quick and easy. If not, it is essential to let the water seep in naturally before mixing, with a rest period of twenty-four or forty-eight hours; only then can you mix with a spatula.

Rooster

Designed like a game of assembling and deforming, this rooster is constructed from a slab, working sometimes on softening it, sometimes firming it up. Time management is made easier here by the use of the paper clay.

Techniques Used

- Slab construction
- Wet on wet assembly
- Pinch building
- Glazing
- Electric kiln firing

Supplies

- 9.9 lbs. (4.5 kg) of stoneware paper clay with medium fiber content
- 1 piece of burlap 24 x 24 in. (60 x 60 cm)
- 1 rolling pin
- 2 laths 0.2 in. (5 mm) thick
- 2 laths 0.12 in. (3 mm) thick
- 1 knife
- 1 banding wheel
- 1 jar of paper clay slip (7 oz./200 g of paper clay + 4.25 oz./120 g water)
- 1 flat paintbrush
- 1 wood modeling tool
- 1 scouring sponge
- 1 hair dryer
- 1 spatula
- 1 ribbon tool
- 1 jar soft paper clay (7 oz./200 g of paper clay + 0.7 oz./20 g water)
- About 1.7 oz. (5 cl) orange glaze for stoneware to be applied with a brush
- About 6.75 oz. (20 cl) white glaze for stoneware to be applied with a brush
- About 6.75 oz. (20 cl) black glaze for stoneware to be applied with a brush

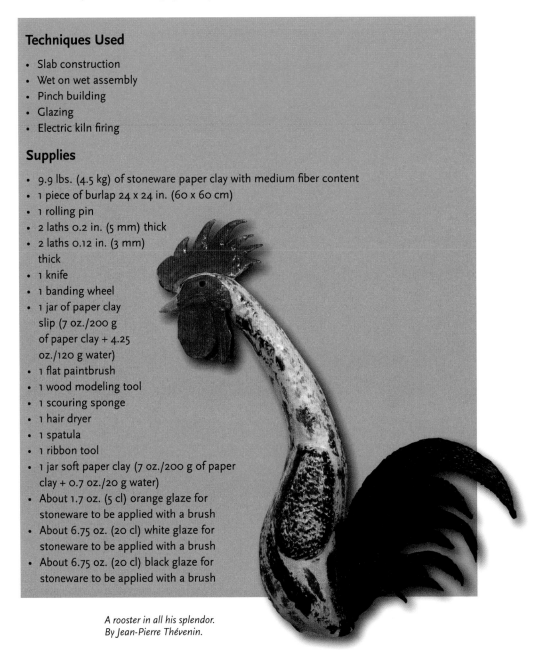

A rooster in all his splendor.
By Jean-Pierre Thévenin.

1 On a work surface covered with burlap, use a rolling pin to roll out a 0.3 in. (8 mm) thick slab using 3.3 lbs. (1.5 kg) of paper clay (see technique on p. 67). Then cut a rectangle about 10 x 15.75 in. (25 x 40 cm) from the slab.

2 Place the slab on a turntable or banding wheel, forming a cylinder with edges overlapping by about 0.4 in. (1 cm). Coat the contact areas with paper clay slip using a brush. Then press the join and go over it with a wood sculpting tool, inside and out.

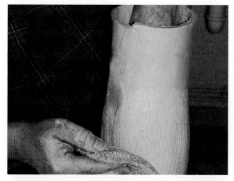

3 Pass a wet scouring sponge over the cylinder to scrape the surface and soften it. Shape by pushing from the inside with your fingers.

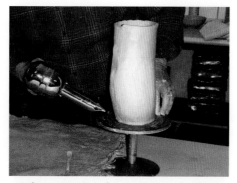

4 Before proceeding, firm up the base by blowing hot air on it with a hair dryer on its highest setting. Place a strip of paper clay covered in paper clay slip inside the opening to reinforce both sides of the join with the second slab.

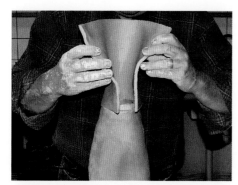

5 Roll out the second slab to 0.2 in. (5 mm) thick. Cut a slight trapezoid shape and position it on the base. Carefully smooth the surface of the join coated with paper clay slip.

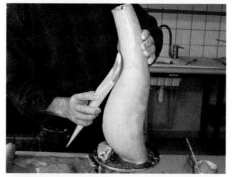

6 Stabilize the piece at the base with a paper clay coil. Tap with a spatula to shape. To firm up, leave for one to two hours in the open air or use a hair dryer.

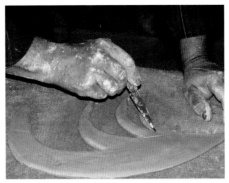

7 Lay out a new 0.2 in. (5 mm) thick slab and cut out feathers to form the tail. Make two more sets of smaller feathers. Smooth them with a damp sponge to refine the edge and mark the surface with a round-ended ribbon tool. To firm them up, leave them for one to two hours in the open air or use a hair dryer.

8 Place the body of the rooster on a bed of fabric to attach the three sets of feathers vertically, one at a time. Coat the body and base of the feathers with paper clay slip and press them together. Reinforce the join with soft paper clay and smooth it out.

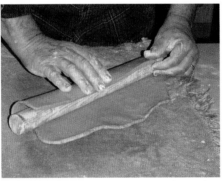

9 Shape a slab around a rolling pin to be used to lengthen the neck. Then cut and weld the overlapping edges and roll the whole thing on the work surface to even it out.

10 Assemble the neck after placing a reinforcing strip as before. Carefully work on the joins, remove the rolling pin, and curve the neck. Firm up with the hair dryer to hold it in place.

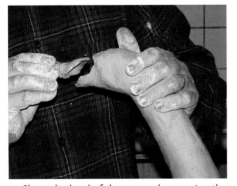

11 Shape the head of the rooster by pressing the fingers on the wall of the opening. Add small, flattened pieces of clay and close it little by little. Shape the beak joined to an end piece and close the opening by smoothing with your fingers.

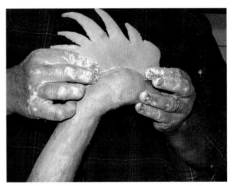

12 With a knife, cut out the rooster's comb from a 0.2 in. (5 mm) thick slab and refine its outer edge. Coat the thick part with paper clay slip and place it on the head. Then mold two wattles and two earlobes, and attach them in the same way.

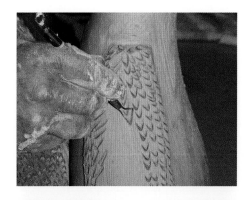

13 Roll out and cut two slabs to be joined on each side of the body (surfaces previously coated with slip) to form the wings. Mark the feathers by pressing with a ribbon tool.

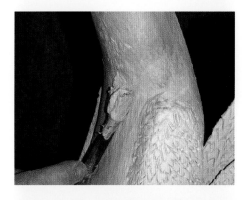

14 Mix the leftover paper clay slip and soft paper clay and coat the rooster with a brush. Even out the surface while leaving irregular marks to represent the feathers. Let dry for a few days in the open air.

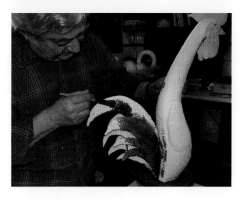

15 Apply the glazes with a brush, side by side or by layering. Fire at 2336°F (1280°C).

Assembling the rooster

The rooster can be assembled in one go if you use a hair dryer or heat gun whenever necessary to stabilize or firm up the paper clay. All the firming steps can be replaced by letting it sit in the open air; it is then necessary to prop the neck with a support to hold it in place.

Giraffe

The long legs of this giraffe are assembled wet on dry, thanks to the hydrophilic qualities of paper clay and its resistance to drying shrinkage. The elongated neck is kept stable by forced firming while working on it. Creating this giraffe pushes the technique of paper clay to its limits, and it requires both patience and the ability to respond quickly.

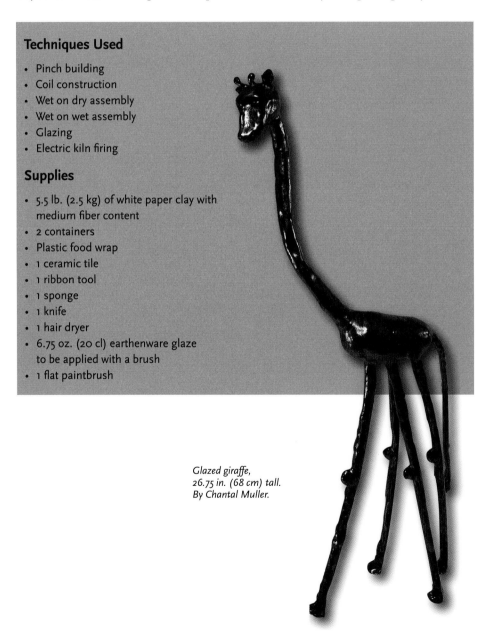

Techniques Used

- Pinch building
- Coil construction
- Wet on dry assembly
- Wet on wet assembly
- Glazing
- Electric kiln firing

Supplies

- 5.5 lb. (2.5 kg) of white paper clay with medium fiber content
- 2 containers
- Plastic food wrap
- 1 ceramic tile
- 1 ribbon tool
- 1 sponge
- 1 knife
- 1 hair dryer
- 6.75 oz. (20 cl) earthenware glaze to be applied with a brush
- 1 flat paintbrush

Glazed giraffe,
26.75 in. (68 cm) tall.
By Chantal Muller.

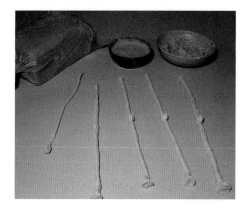

1 Two days before assembling the giraffe, shape the legs and tail and let them air dry. In one container, cover 0.55 lb. (250 g) of paper clay with 5 oz. (15 cl) of water to form paper clay slip. Spread 1.1 lb. (500 g) of paper clay in the bottom of the second container and wet the surface with 1.7 oz. or 5 tablespoons (5 cl) of water to form a soft paper clay. Cover with plastic food wrap and let the water soak in for two days without intervention.

2 Wrap the bottom of the legs with plastic wrap to protect them against moisture.

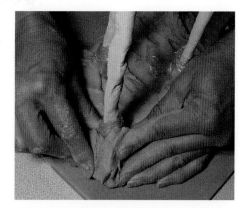

3 Position the legs and hold them in place on a ceramic tile with paper clay.

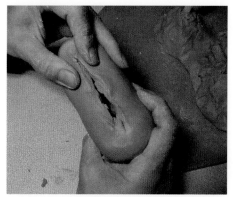

4 Shape the body of the giraffe, hollow it out with a ribbon tool to make it lighter and close the opening by pinching the clay with your fingers.

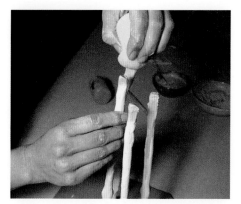

5 With a wet sponge, moisten the top of the legs to be joined, then coat generously with paper clay slip.

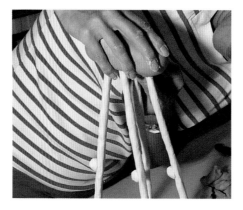

6 Pierce the bottom of the body to make four openings that are only slightly larger than the diameter of the legs, using a knife or piercing tool. Push the legs inside the body and use soft paper clay to attach them. Put the tail in place in the same way.

7 Roll a piece of paper clay on the work surface to form a long coil to make the neck. Adjust its length.

8 Shape the giraffe's head. Attach ears and horns with paper clay slip. Hollow out the head from underneath to make it as light as possible, and fit an opening to match the diameter of the neck.

9 Dip the top of the neck in paper clay slip before attaching the head. Place the neck and head on the work surface, curve them, and firm them up with the hair dryer.

10 Create an opening in the body and stick in the bottom of the neck coated with paper clay slip. Use soft paper clay to shape the connection.

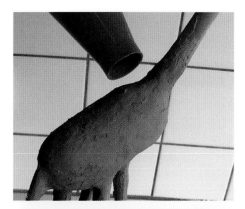

For this tall, willowy piece, it is essential to avoid sagging of the neck, due to the unstable position and extension of the neck, both during the shaping and firing. It is best to use grogged stoneware and to apply an earthenware glaze.

11 Firm up the connection with the hot air of a hair dryer.

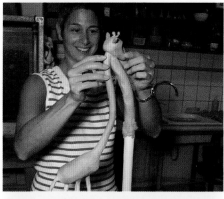

12 Hold it up with a support, here in dry paper clay with an extension made from a coil of firm paper clay for molding, and let it firm up for two hours in the open air.

13 Remove the support and let it dry for another few days, protecting the clay base with plastic wrap so that it remains moist (it can then be easily removed when the giraffe has dried completely).

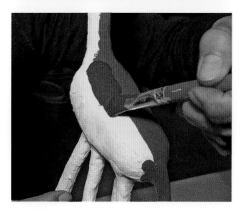

14 Apply the glaze with a flat brush. Apply a second coat when the first coat is dry. Place the giraffe in the kiln without forgetting the kiln supports, and fire at 1832°F (1000°C) (stay well below the maximum firing temperature of the clay).

Glossary

Banding wheel

A revolving plate that is turned by hand, used to place the clay to assemble or decorate it on all sides without having to handle it.

Bisque

The state of a fired clay ready to receive a glaze suspension.

Bisque firing

Firing traditionally done to harden clay in preparation for glazing. It is also called first firing.

Bound water

Water chemically incorporated into the molecules of a material. Bound water, also called water content, is eliminated during the firing of the clay between 752 and 1292°F (400–700°C).

Casting

The technique of pouring a slip into a plaster mold to make a piece. Once the wall is formed from coming in contact with the water-absorbing plaster, the excess slip is removed.

Cellulose

Long molecular chain composed of glucose elements, forming the cells of plants, the smallest dissociable element of which is the fiber. The cellulose fiber is hollow and hydrophilic.

Ceramics, Pottery

Objects made of clay hardened by fire. By extension, the manufacture of these objects and the activity itself.

Clay

Mineral material based on hydrated alumina silicates. It becomes malleable when mixed with water and hardens irreversibly during firing.

Cohesion

The property of like molecules of a material sticking together and resisting external actions.

Coil

Clay shaped in a long cylinder. The coil technique consists of layering coils and welding them to each other to assemble pieces.

Density

Ratio between the mass (weight) of a body and the mass of an equivalent volume of water. The density of paper clay is lower than that of traditional clay.

Earthenware

Common clay that can be fired between 1652 and 2012°F (1100°C). Earthenware remains porous after firing.

Engobe

A mixture of clay and water, often with added coloring oxides. The slip is used to coat or decorate the ceramic body. It is generally covered with a transparent glaze.

Fiber

Fibers are thin, elongated cells. Plant fibers are about 20 μm across with an average length of 1 mm in a hardwood and 3 mm in a softwood. A flax fiber can reach 50 mm.

Fiber Clay

Clay containing fibers, whether vegetable (cellulose), mineral (glass, ceramic), or synthetic (nylon, polyester).

Flux

Additive used to improve the fusion of clay or glaze.

Free water

Water that circulates freely in a material. In the case of clay, this water is eliminated by evaporation on contact with the air. It is absorbed when in contact with water.

Glaze

Mixture of silica, fluxes, and oxides. Put in suspension in water and applied to the clay, glaze turns into a vitreous layer when its melting point is reached during firing.

Glaze Firing

Firing that transforms the glaze powder into a glassy material. It is also called second firing when it follows the bisque firing.

Glazing

The action of applying one or more layers of glaze to a dry fired piece or, more generally, a bisque piece.

Grog

Small pieces of ground fired clay added to clay to improve its properties. Grog facilitates the assembly of large pieces. The granular size of grog varies from 0 to 2 mm.

Grogged Clay

A mixture of clay, grog, and water commonly used for hand-building and sculpting. Grog reduces the shrinkage of a clay and regulates the diffusion of water, thus reducing the formation of cracks and deformations.

Hand-building

Shaping of a block of clay using the pressure of your fingers.

Hollow Out

To remove excess clay to form a hollow volume, to lighten a piece, to refine its walls, or to facilitate drying.

Kanthal Wire

Kanthal is the brand name of a wire made with an alloy based on iron, chromium, and aluminum, supporting the high temperatures of ceramic kilns.

Leather Hard

A particular consistency of a mass of clay that is still wet but has become firm enough that it hardly ever deforms.

Macromolecule

Large molecule formed by the ordered and periodic association of many basic molecular structures.

Malleability

Property of a substance that is able to be flattened and shaped.

Maturation

Optimal degree of solidity of a clay obtained by a high firing temperature (before the fusion stage).

Melting

Passage of material from a solid to a liquid state. The firing of a glaze is stopped when its melting point is reached.

Mullite

A needle-like crystal that appears in the final phase of firing stoneware and porcelain, during the vitrification process. Mullite gives great strength to the fired pottery. Its chemical formula is $3Al_2O_3 \, 2SiO_2$.

Nylon

Originally a brand name, nylon has become a generic term for a synthetic fiber based on polyamide. Nylon fiber is solid and hydrophobic.

Oxide Dye or Metal Oxide

Fine powder of oxidized metal that colors a glaze, engobe, or clay. The metal is bound to oxygen. Depending on the amount of oxygen released during firing, the final coloring varies.

Paper Clay

Clay prepared with fibers from a paper pulp, sometimes known as fiber clay. The fibers are cellulose-based. Paper clay makes it easier to assemble pieces and increases their cohesion in the dry state.

Paper Clay Slip

A mixture of clay, water, and cellulose-based fibers. Paper clay slip is used to fill cracks, attach or join parts, or smooth a surface. Paper clay results from reducing the water content of this slip.

Plasticity

Property of clay that allows it to take on various shapes without cracking and to keep them.

Polyester

Synthetic material used for the manufacture of textile fibers. They are solid and have little affinity for water.

Porcelain

Very white clay whose basic component is kaolin. Firing at around 2372°F (1300°C) makes it compact, translucent, and almost vitrified.

Raku Firing
Rapid firing technique originating from Japan. An item being fired is removed from the kiln at the point of glaze melt, the thermal shock causing crackling on its surface.

Rib
A wooden, rubber, metal, or plastic often kidney-shaped tool used to scrape and smooth the clay.

Ribbon Tool
A tool consisting of a sharp or round metal ring attached to a handle and used to remove excess clay.

Self-hardening Clay
Clay containing a hardener to reduce its brittleness when dry. The pieces made are not intended to be fired, but they can be.

Shard
This term designates a piece of broken ceramic.

Shrinkage
Reduction of the size of a piece due to the evaporation of water and the transformation of the clay into a hard material.

Slab
A technique of using clay spread out with a roller (e.g., to form the wall of a piece).

Slab Roller
Professional equipment for making clay slabs, consisting of a tray and a roller.

Slip
A mixture of clay and water in varying amounts. With a thick slurry consistency, slip is used to glue parts to be assembled. Liquid and thin, the slip is used to make pieces in plaster molds.

Stamping
Action of pressing clay against a stamp or embossing plate to transfer the shape and structure of the pattern.

Stoneware
Clay that can be fired between 2192°F (1200°C) and 2372°F (1300°C). During this firing, the stoneware undergoes a beginning of vitrification; it becomes waterproof and frost resistant.

Terra Sigillata
Ceramic covered with an engobe composed of very fine particles of clay, which gives it a soft satin appearance.

Throwing
Shaping with the hands of a block of clay in rotation on a potter's wheel.

Trimming
Work of refining and finishing a thrown piece, carried out after it has become leather hard.

Vitrification
Transformation of a substance into glass or a substance having the appearance of glass.

Wheel Head
Revolving piece mounted on a pottery wheel on which the clay is shaped.

Wood Modeling Tool
A wooden tool of various shapes and sizes used to work the clay in its smallest recesses.

Webography

Ceradel
Supplier of ceramic and glass products and equipment for industry, crafts, and hobbies. Offers paper clays. https://www.ceradel.fr/en/

Ceramic Arts Network
The American Ceramic Society website, with helpful information and demonstrations on working with paper clay. https://ceramicartsnetwork.org

Copacel
Representation and support of the paper industry by the French Union of Cardboard, Paper and Cellulose Industries. http://www.copacel.fr/en

Dynamic
Manufacturer of various models of powerful mixers for community kitchens. http://www.dynamicmixers.com

French Society of Ceramics
The SFC carries out applied research on all ceramic products. Expertise and certifications. https://ceramique.fr/?lang=en

Graham Hay
Graham Hay lives in Australia, builds with paper clay, and sculpts compressed paper. His site offers many links to artists and publications on paper clay. http://www.grahamhay.com.au

Keramik-Kraft
Online sale of paper clays, slips, powdered clays, and cellulose fibers. https://www.keramik-kraft.com/en

Laguna Clay Company
Distributes Axner Paper Clays and other supplies such as glazes, kilns, wheels, etc. https://www.axner.com

Paper Clay Products
Online sales of cellulose fibers and fibers mixed with powdered clay. http://www.paperclay.co.uk

Scarva
Supplier of ceramic products and equipment, exporter of the Scarva FLAX Paper Clay line from Northern Ireland. Markets fiber clays and slips as well as high-temperature-resistant wire for armatures. http://www.scarva.com

Solargil

Producer of raw materials and supplier of ceramic products and materials for professionals and creative hobbies. Offers various paper clays. https://en.solargil.com/

Terrepapier.com

Liliane Tardio-Brise's website dedicated to information and news about paper clay, as well as complementary resources to this book. http://www.terrepapier.com/paperclay-en.php

Further Reading

Fibers, Cellulose, Paper

BIERMANN C.J., *Handbook of Pulping and Papermaking*, Academic Press (United States), 1996.

CLARKE A.J., *Biodegradation of Cellulose. Enzymology and Biotechnology*, CRC, 1996.

CROSS C.F., BEVAN E.J., BEADLE C., *Cellulose*, Elibron, 2000.

HAIGLER C.H., WEIMER P.J., *Biosynthesis and Biodegradation of Cellulose*, Marcel Dekker, 1991.

KENNEDY J.F., PHILLIPS G.O., WILLIAMS P.A., *Cellulose and Cellulose Derivatives*, Woodhead Publishing, 1995.

MARSH J.T., *An Introduction to the Chemistry of Cellulose*, Osler Press, 2007.

PINTO B.M., *Comprehensive Natural Products Chemistry. Carbohydrates and Their Derivatives including Tannins Cellulose and Related Lignins*, Pergamon, 1999.

ROBERTS J.C., *Paper Chemistry*, Springer, 1996.

Ceramics

ASE A., *Water Colour on Porcelain: A Guide to the Use of Water-Soluble Colourants*, Norwegian University Press, Oslo (Norway), 1989.

BOSWORTH J., *Ceramics with Mixed Media*, A & C Black Publishers (Great Britain), 2006.

BROOKS N., *Mouldmaking and Casting*, Crowood Press (Great Britain), 2005.

CONNEL J., *Colouring Clay*, A & C Black Publishers (Great Britain), 2007.

CONRAD J.W., *Advanced Ceramic Manual. Technical Data for the Studio Potter*, Falcon Company Publishers (United States), 1989.

CONRAD J.W., *Ceramic Formulas: The Complete Compendium*, MacMillan Publishing (United States), 1978.

CONRAD J.W., *Contemporary Ceramic Formulas*, MacMillan Publishing (United States), 1980.

COOPER E., *A History of World Pottery*, B.T. Batsford (Great Britain), 1981.

COOPER E., *Electric Kiln Pottery*, B.T. Batsford (Great Britain), 1982.

COOPER E., *The Potter's Book of Glaze Recipes*, A & C Black Publishers (Great Britain), 2004.

DOHERTY J., *Porcelain*, A & C Black Publishers (Great Britain), 2002.

EITEL W., *The Physical Chemistry of the Silicates*, University of Chicago Press (United States), 1954.

FINCH J., *Kiln Construction*, A & C Black Publishers (Great Britain), 2006.

GAULT R., *Paper Clay*, University of Pennsylvania Press (United States), 1998-2005.

GAULT R., *Paperclay: Art and Practice*, University of Pennsylvania Press (United States), 2013.

GAULT R., *Paperclay for Ceramic Sculptors: A Studio Companion*, New Century Art Books (United States), 1993-2010.

GREGORY I., *Alternative Kilns*, A & C Black Publishers (Great Britain), 2005.

GREGORY I., *Kiln Building*, A & C Black Publishers (Great Britain), second edition, 2002.

HAMER F., HAMER J., *The Potter's Dictionary of Materials and Techniques*, University of Pennsylvania Press (United States), fifth edition, 2004.

JEOUNG-AH K., *Paper-Composite Porcelain*, The School of Design and Crafts HDK, Göteborg University (Sweden), 2006.

JONES D., *Firing. Philosophie within Contemporary Ceramic Practice*, Crowood Press (Great Britain), 2007.

LANCET M., *Japanese Wood-fired Ceramics*, Krause Publications (United States), 2005.

LANE P., *Contemporary Porcelain*, A & C Black Publisher (Great Britain), second edition, 2003.

LIGHTWOOD A.,*Working with Paperclay and other Additives*, Crowood Press (Great Britain), 2000.

MANSFIELD J., *Ceramics in the Environment. An International Review*, American Ceramic Society (United States), 2005.

MINOGUE C., SANDERSON R., *Wood-fired Ceramics. Contemporary Practises*, A & C Black (Great Britain), 2000.

MINOGUE C., *Slab-Built Ceramics*, Crowood Press (Great Britain), 2008.

NELSON G.C., *Ceramics. A Potter's Handbook*, Holt Rinehart and Winston (United States), 1971.

POULTON I., *Fired up with Raku. Over 300 Raku Recipes*, Crowood Press (Great Britain), 2006.

ROBINSON J., *Large-Scale Ceramics*, A & C Black Publishers (Great Britain), second edition, 2005.

SCOTT D., *Clays and Glazes in Studio Ceramics*, Crowood Press (Great Britain), 1998.

SCOTT P., *Ceramics and Print*, A & C Black Publishers (Great Britain), second edition, 2005.

TICHANE R., *Ash Glazes*, Krause Publications (United States), 1998.

TICHANE R., *Celadon Blues*, Krause Publications (United States), second edition, 1998.

TICHANE R., *Copper Red Glazes*, Krause Publications (United States), second edition, 1998.

WANDLESS P.A., *Image Transfer on Clay. Screen, Relief, Laser & Monoprint Techniques*, Lark Books (United States), 2006.

WARDELL S., *Porcelain and Bone China*, Crowood Press (Great Britain), 2004.

WARDELL S., *Slipcasting*, A & C Black Publisher (Great Britain),second edition, 2007.

Articles and Publications on Paper Clay

ACHAR S., "The Paperclay TODAY Conference and Symposium, Laguna Beach 2010," *Ceramics Technical*, 2010, 31, 39–42.

ACOTT-FOWLER L., "Creative Process of Paperclay," *Sculptural Pursuit Magazine*, 2005, winter, 43–47.

ALLIBAND K., "Fibre Clay Revolution," *Pottery in Australia*, 2004, 43 (1).

AMOS A., "Paperclay: Material that Does Not Play by the Rules," *Ceramic Art Association of Israel*, 2010, 48–51.

AYLIEFF F., "Working with Paperclay and other Additives," *Ceramic Review*, 2001, 189 (May-June), 56.

BAKER W.L., "Spraying Paper-Reinforced Clay," *Ceramics Monthly*, 1998, 46 (9), 46–49.

CAMPBELL-ALLEN B., "Where There's Smoke . . . Paperclay in the Anagama," 1997, *Pottery in Australia*, 36 (1), 16–18.

CANDURAN K., CANDURAN C., "Paperclay Research from Turkey," *Ceramics Technical*, 2008, 26, 100–02.

CAPLAN J., "Paper and Clay," *Ceramic Review*, 1993 (144), 11.

CAPLAN J., "Paperclay Again," *New Zealand Potter*, 1994 (1), 18.

DIETRICH S., "Storytelling and Paperclay (school project)," *Pottery in Australia*, 2001, 40 (3), 70–72.

ELLERY D., "Profile: Sold on Paperclay," *Pottery in Australia*, 1995, 34 (1), 20–21.

FARROW C., "Paper/Clay," *Artists Newsletter*, 1987 (April), 20–21.

FUZI L., "Margit Gerle's Biomorphs," *Ceramics Art and Perception*, 2002, 49, 96–97.

GARTSIDE B., "Mix What with Clay?" *New Zealand Potter*, 1993, 35 (3), 32–33.

GARTSIDE B., "Suitcase Art," *New Zealand Potter*, 1994, 36 (1), 17.

GAULT R., "Amazing Paperclay," *Ceramics Monthly*, 1992 (June/July/August), 96–99.

GAULT R., "A Potential for Paperclay Water Filters: An Artist's View," *ICS 2011: Ceramic Arts and Design for a Sustainable Society*, Sweden, 2011, 92–111.

GAULT R., "Rules, Rules, What Rules? Sculptural Freedom with Paper Clay," *Ceramic Review*, 1996 (June/July/August), 77–80.

GAULT R., "Second Generation Ceramics," *Interaction in Ceramics, Art, Design, Research*, UIAH Helsinki, 1993, 75–79.

GAULT R., "Success with Large Scale Paperclay Porcelain and Beyond," *Ceramics Technical*, 2004, 18 (1), 99–103.

GAULT R., "The Magic of Paperclay," *Ceramic Review*, 1995 (155), 10–13.

GAULT R., "The Potential of Paperclay," *Ceramics Art and Perception,* 1994 (18), 81–85.

GOLDATE S., "Paperslip," *Ceramics Today*, 2003.

GOLDATE S., "Working with Paperslip," *Ceramics Technical*, 2001, 13, 78–80.

HARRISON S., "The Making of Paperclay Porcelain Banners," *Pottery in Australia*, 1998, 37 (2), 68–69.

HAWES W., "Building a Paperclay Dragon," *Ceramics Art and Perception*, 1998, 7, 36–38.

HAY G., "A Paperclay Update," *Ceramics Technical*, 2006, 22, 37–40.

HAY G., "A Skateable Sculpture: Using Paperclay as a Design Medium," *Pottery in Australia*, 2002, 41 (1), 42–43.

HAY G., "Ancient Tribe Project," *Australian Ceramics & Pottery*, 1999, 1 (2), 52–56.

HAY G., "Don't Be Petrified, It's Not Paper, It's Fiber, Yeast and Fungi in Your Clay," *Australian Ceramics Triennale Paper*, Adelaide, 2012.

HAY G., "More on Paperclay," *Ceramics Technical*, 1996, 3, 22–28.

HAY G., "The Paperclay and Digital Revolution," *ICS 2011: Ceramic Arts and Design for a Sustainable Society*, Sweden, 2011, 75–84.

HAY G., "The Paperclay Revolution," *National Council on Education for the Ceramic Arts Journal*, 2007, 28, 104–05.

HAY G., "What Haven't You Been Doing with Paperclay?" *Journal of Australian Ceramics*, 2012, 513, 44–47.

HAY G., "Why Burn Paper?" *Journal of Australian Ceramics*, 2007, 46, 84–86.

HAY G., "Why Paperclay?" *ArtEd Journal*, 2000, 2, 8–9.

HAY G., "With But Not on Paper," *Pyre CGA Journal*, 1996, 9, 4–5.

HAY G., "Workshop: The Paperclay Revolution," *Journal of Australian Ceramics*, 2009, 48 (3), 78–81.

JEOUNG-AH K., "The Characterisation of Paper Composite Porcelain in a Fired State by XRD and SEM," *Journal of the European Ceramic Society*, 2004, 24 (15-16), 3823–31.

JEOUNG-AH K., "The Characterisation of Paper-Composite Porcelain in a Green State," *Journal of the European Ceramic Society*, 2006, 26 (6), 1023–34.

JUVONEN L., "Using Paper Fiber as a Substitute in Ceramic Clay," *8th CIMTEC World Ceramics Congress*, 1994, Finenze, Italy, 193–200.

LIGHTWOOD A., "Playing with Paperclay," *Ceramic Review*, 1995, 156, 18–19.

MAU L., "Paperclay and Steel," *Ceramics Monthly*, May 1997, 45, 5.

MICHAUD J., "Paperclay Sculpture with Ian Gregory," *Clay Times*, September/October 1999, 11–13.

NELSON L., "Karen Smith-Sculpture in Paperclay," *CSG Newsletter*, June 1998, 4–5.

RASSELL J., "Paperclay, Rosette Gault at NCECA," *New Zealand Potter*, 1993, (2), 20.

SACCARDO M., "Possibilities with Paperclay," *Pottery in Australia*, 2004, (42), 2, 74.

SMITH H., "Flexography: Photographic Relief Printing on Paperclay," *Ceramic Review*, May/June 2001, 189.

SOONG D.-K., LING Y.-C., "Determination of PCDD/DFs in Paper Clay Samples," *Chemosphere*, 1995, 30 (9), 1799–803.

SPENCER-COOKE A., "Porcelain Documents," *Ceramics Monthly*, December 1996, 91.

STEVEN G., "An Investigation into Properties of Porcelain Paperclay," *Ceramics Technical*, May 2002, 72–77.

VALMADRE J., "Barbecued Clay. Yum!" *Journal of Australian Ceramics*, 2009, 48 (3), 44–47.

WILSON L., "Paper Clay. Yes!" *Clay Times*, Winter/Spring 2013, 25–26.

Periodicals Specializing in Ceramics and Artistic Creation

American Ceramic Society Bulletin. United States.

Art New England. United States.

Ceramic Review. Great Britain.

Ceramics Art and Perception. Australia.

Ceramics International.

Ceramics Monthly. United States.

Ceramics Technical. Australia.

Clay Times. United States.

Fired Arts and Crafts. United States.

Journal of Australian Ceramics. Australia.

Journal of the American Ceramic Society. United States.

Journal of the Australian Ceramic Society. Australia.

Journal of the European Ceramic Society.

Pottery Making Illustrated. United States.

The Studio Potter. United States.

Table of Contents

Acknowledgments

My warmest thanks to all those who contributed to the completion of this book:

Élisabeth de Montmarin, deputy editorial director of Éditions Eyrolles, for her confidence and support, Florian Migairou, project editor, and the entire team that participated in creating the book;

Joe Tardio, who helped the project move forward with his wisdom and logistical support, especially for the photos;

the city of Saint-Louis (Haut-Rhin) and the association Les As du Temps Libre, who allowed me to develop the paper clay project in the pottery studio at La Maison pour Tous, the regulars of the pottery workshop of La Maison pour Tous in Saint-Louis, who knew how to innovate and make the most of the creative and playful possibilities of paper clay: Lilli and Marcel Ball, Marie-Claire Fuchs, Fabienne Glauser, Paulette Guisset, Sylvie Hug, Clémence Lang, Rachel Meiss, Chantal Muller, Jocelyne Nargues, Alexandre Racine, Rose-Marie Rapp, Ursula Sevin, Jean-Pierre Thévenin, and Jeanine Wolgensinger;

the association Exprime and the trainees in Yenne (Savoie), for whom clay was a discovery and paper clay a good material for expressing themselves;

Caterine Beaugé, gallery owner in La Romieu (Gers), always ready for new artistic experiences;

Floriane Maehr and Raphael Tardio, who allowed me to explore the possibilities of paper clay in the field of arts and crafts;

Sharon and Richard Baker, sculptors-founders in Ailloncourt in Haute-Saône, who shared their experience and cast bronze in paper clay molds instead of a type of banco (similar to adobe). Thanks to Philippe Zinck for his collaboration;

Graham Hay, who collects information on paper clay from around the world, including the references of publications reproduced here with his agreement and warm encouragement;

the ceramicists who spontaneously spoke about their experience with paper clay and made available illustrations of their work: Xavier Duroselle, Claire and Charles Eissautier, Carol Farrow, Wayne Fischer, Thérèse Lebrun, Élisabeth le Rétif, Pierre Ohniguian, Henri Schmeltz, Anne-Marie Schoen, Nina Seita, Otakar Sliva, Karin Stegmaier, and Barbara Wagner. Thanks also to the photographers and collectors who gave their permission for publication.

Photo credits

All photographs are the property of the author, with the exception of the following: p. 18, *With Nothing But*, A. Zorninger; p. 23 and cover, *2 cylinders, scoops, bases*, C. Farrow; p. 28, *Coral* and close-up, P. Gruszow; p. 35, *Rhythms*, K. Stegmaier; p. 45, *Arch*, C. Farrow; p. 58 and 80, *Earthenware Jar*, P. Ohniguian; p. 59, *Alésia*, N. Seita; p. 69, *Untitled*, W. Fischer; p. 71, *Double-walled bowl* and its assembly, X. Duroselle; p. 74, *Pears*, P. Henry and the assembly of a pear, N. Hubert; p. 75, *Phrygane*, P. Gruszow; p. 77, *The Misfortunes of War—Baghdad*, E. le Rétif; p. 86, *Pushmi-Pullyu*, O. Sliva; p. 86, *Gazelle*, H. Schmeltz; p. 87, *Dostera* and close-up, N. Seita; p. 89, Jar, P. Ohniguian; p. 91, *Boustrophédon*, E. le Rétif; p. 92, *Whirlwind* and close-up, K. Stegmaier; p. 93, *Calcification*, P. Gruszow; p. 95, *Man's head* and stages of making it, H. Schmeltz; p. 95, *Pebble* and molds, C. Eissautier; p. 96, *Didie*, E. le Rétif; p. 98, *Architecture* and slabs, C. Eissautier; p. 107, *Untitled*, W. Fischer; p. 108, *Crucibles*, C. Farrow; p. 112, *Tisiphone* and its firing, N. Seita; p. 113, *Bull* (Stier), H. Schmeltz.